MW01009959

IMAGINATION IS REALITY

Western Nirvana in Jung, Hillman, Barfield, and Cassirer

by

Roberts Avens

Spring Publications, Inc.
Dallas, Texas

This book was edited by Randolph Severson, Gary Bedford, and Dana C. Anderson and designed by Kate Smith Passy.

An earlier version of this work was published (1979) under the title *Imagination: A Way toward Western Nirvana*, University Press of America, Inc., Washington, D. C. ISBN 0-8191-0697-6; LCC 78-68693.

Printed in the United States of America by Braun-Brumfield, Inc., Ann Arbor, Mich., for Spring Publications, Inc., P. O. Box 222069, Dallas, Texas 75222

International Distributors:
Spring, Postfach, 8800 Thalwil, Switzerland
Japan Spring Sha, Inc.; 31, Shichiku-Momonomoto-Cho; Kitaku, Kyoto, 603 Japan
Element Books Ltd; The Old Brewery Tisbury Salisbury; Wiltshire SP3 6NH; England

ISBN 0-88214-311-5

CONTENTS

Introduction: The Forgotten 'Third'

There is little doubt that Western infatuation with Eastern spiritual disciplines, ostensibly designed to transcend or extinguish the illusion of the 'Ego,' has reached an impasse. Instead of offering an alternative way to transforming Western consciousness, these disciplines have been converted into subtle devices for enhancing its insatiable desire for light, power and control. Once again it is as in the old Chinese saying: "If the wrong man uses the right means, the right means works in the wrong way." In effect, it is the Western belief in the right method irrespective of the man who applies it that seems to be responsible for the impasse, because method alone, divorced from the psyche, only breeds the delusion of technical omnipotence.

What has in fact ensued from the artificial transplantation of Eastern values into Western soil is a kind of "spiritual materialism" — using "spiritual activities" in order to bolster and enrich one's ego.[1] We may call this phenomenon the hydra syndrome: like the mythical Hydra whose cut-off head is always replaced by two others, the adept's 'innermost self,' the perennially selfsame and boring ego, aching for transcendence, appears to reemerge, strengthened and solidified, as a direct result of the methodical attempt to cut it down to size. Another word for this sort of uncontrollable growth is *hubris*, misleadingly translated "pride." *Hubris* is from the Greek *hubridzo* which means "to run riot." Applied here it denotes that frantic search for new spiritual experiences issuing in "the mania of an ego's vertigo, endlessly spinning about its own center."[2] In a larger

setting *hubris* is the flaw of a grotesquely excessive masculinity and rationality.

It could be maintained that the sense of dis-ease and up-rootedness which afflicts us all is largely due to a confusion of the spiritual with the rational. The rational man (Aristotle's *zoon logon echon*) is above all fascinated with the conquests of his conscious mind. He identifies himself with what Jung called "directed thinking" (in contrast to "fantasy thinking") the clearest expressions of which are science and technology.[3] When Eastern spirituality is embraced by rational wars as a panacea, a cure-all for every conceivable ill, the result is a man who would do anything to avoid facing his own soul. People will practice Indian Yoga, observe a strict regimen of diet, mechanically repeat mystical texts — only because of the lack of faith that anything good could ever come from their own souls.[4] Jung warns therefore that instead of mindlessly borrowing from the treasures of the East, we should attempt to shape our lives out of our own psychic roots.

> We must get at the Eastern values from within and not from without, seeking them in ourselves, in the unconscious . . . If we snatch these things directly from the East, we have merely indulged our Western acquisitiveness, confirming yet again that 'everything good is outside,' whence it has to be fetched and pumped into our barren souls.[5]

James Hillman, the first inspired deviationist from Jungian orthodoxy, brings us nearer to the central concern of this essay in the following observation.

> In the East the spirit is rooted in the thick yellow loam of richly pathologized imagery — demons, monsters, grotesque goddesses. tortures and obscenities . . . But once uprooted and imported to the West it arrives debrided of its imaginal ground, dirt-free and smelling of sandalwood.[6]

These two observations, taken together, emphasize that Eastern values must be discovered from within, or the 'unconscious,' and, furthermore, that the unconscious is identical with the imaginal ground from which all purely spiritual doctrines and disciplines must grow if they are to be effective in a particular, historically circumscribed setting. Before distin-

guishing in a preliminary way the imaginal from the spiritual, it is necessary to specify the sense in which some of the key terms of Eastern traditional spirituality, or 'the Eastern way,' will be used throughout these pages.

To begin with *nirvana,* the word means literally a "blowing out," "not transitively, but as a fire ceases to draw . . . when the mind has been curbed, one attains to the 'peace of Nirvana,' 'despiration in God' . . . the peace is reached that 'passed understanding.'"[7] *Nirvana* is not tantamount to extinction or annihilation. What is extinguished in *nirvana* is the fever of greed, hatred and delusion — defilements which are primarily due to a dualistic frame of mind distinguishing between me and not-me. In Nagarjuna's (2d century A.D. founder of the so-called Madhyamika school of Mahayana Buddhism) teaching, *nirvana* was associated to *sunyata* (emptiness) which stands in the middle between affirmation and negation, eternity and annihilation. Among the most frequent synonyms for *nirvana* or *sunyata* are 'non-duality' and 'suchness.' These words suggest that *nirvana* cannot be the object of a formal, dogmatic theology. One takes reality such as it is ("just so") without trying to master and to control it by means of ideas. In Edward Conze's words, "the doctrine of emptiness is not taught to support any theory against others but to get rid of theories altogether."[8] *Nirvana* is known only by a kind of direct perception — "unknowingly" or perhaps imaginatively — devoid of a subject and object relation. In this sense 'nirvanizing' does not involve an escape from the frightful, unending chain of rebirth — from the pathology of existence — but rather a realization by the bodhisattva (the ideal man in Buddhism) that this world of birth-and-death, the world of *samsara,* is *nirvana.*

Buddhism is essentially iconoclastic in its determination to see through all idols and fixations; it says that enlightenment (*satori* in the Japanese Zen) lies not in ceremonious loftiness or exaltation above commonality, but rather in this very world of our everydayness. The bodhisattva deals with this world and with the pain (*dukkha*) of human existence by combining two contradictory virtues: wisdom and compassion. In his wisdom

Introduction: The Forgotten 'Third'

he sees through the masks of our ego personalities. In his compassion, which leads to a boundless expansion of the self, he identifies himself with more and more living beings. The point of this is that "the Buddhist philosophers differ from philosophers bred in the Aristotelian tradition in that they are not frightened but delighted by a contradiction." They merely state a contradiction in an uncompromising form and then leave it at that."[9] For contradiction is threatening only to the literalistic mind living in unawareness of the Heraclitean maxim that "all things come to pass through the compulsion of strife."[10]

The symbol of *nirvana* is a Buddhist offshoot of the Hindu *advaitist* (non-dual) insight encapsulated in the famous equation *Tat twam asi*, "you are that." The truth of truths, leading to deliverance, is that you, the individual, the *persona*, in some sense resemble the universal principle called *brahman*. On the mythological level where rational inconsistencies are appreciated rather than shunned, *brahman* is also *Maya-Shakti*, the divine play (*lila*) of the universe with all its innumerable gods, goddesses and demons. According to Zimmer *Brahman* is "that through which we live and act, the fundamental spontaneity of our nature. Proteus-like, capable of assuming the form of any specific emotion, vision, impulse or thought." In itself, however, *Brahman* is the unseen, "beyond the sphere and reach of intellectual consciousness;" it lives in the "dark, great, unmeasured zone of height beyond height, depth beyond depth." *Brahman* is identical with the Self or *Atman*, with that which 'sees' in us, but remains 'unseen' by our senses or the intellect. As the ontological ground of all that we are and know, it is "down in the darkest, profoundest vault of the castle of our being, in the forgotten well-house, the deep cistern."[11]

At the same time, however, the Hindu *Atman* is pictured as too far aloof from the trials of a genuinely human existence to be identified with the "soul" of Jungian psychology. In spite of its immersion in the Heraclitean flux, *Brahman-Atman* at times seems to be more akin to the *summum bonum* or the "pure act" of the Schoolmen, in short, to a Spirit who is essentially un-

7

trammeled by the changing and perishable aspects of *maya*. Or, is it the case that the Hindu *Brahman-Atman* and the Buddhist *nirvana-samsara* equations represent a unique synthesis of spirit and soul and that the realization of both *Brahman* and *nirvana* can be conceived as an Oriental mode of release from literal interpretations of reality? Perhaps, then, a Western Nirvana would require that the West first lose itself in the immeasurably vast and dangerous caverns of the imagination before it may reach the heights of Eastern spirituality; for otherwise there is a risk of a monistic adulation of the spirit-principle. First imagination, then spirit. But also: there is no spiritualization without imagination because in the end it is the imagination that 'images' the spirit even when the latter pretends to be independent from the imagination; for spiritual independence or detachment, like everything else humanly created, is a product and a fantasy of the soul. Moreover, we shall also have to maintain as firmly as possible that our fantasies and imaginings are by no means less ontological than the source from which they arise. The soul does not exist in separation from what she does, including her spiritual and material configurations. Neither is she a conglomeration of spirit and matter. The soul *is* precisely, absolutely, unreservedly in the middle. *That* is the *mysterium tremendum et fascinans:* the soul, that strictly *is* not, endows all else with being and meaning.

The adjective "imaginal" comes from the French Islamic scholar Henry Corbin who distinguished it from the derogatory connotation of "imaginary." He proposed this term (or alternatively *mundus imaginalis*) as pointing to an order of reality that is ontologically no less real than physical reality on the one hand, and spiritual or intellectual reality on the other. The characteristic faculty of perception within the *mundus imaginalis* is imaginative power which noetically or cognitively is on a par with the power of the senses or the intellect. According to Corbin, the imaginal world functions as an intermediary between the sensible world and the intelligible world.[12] Let us suggest, then, that what we call "spirit" is rooted in this middle region.

8

Introduction: The Forgotten 'Third'

Before I proceed, however, it is crucial to distinguish as carefully as possible the spiritual from the imaginal (Jung's "fantasy thinking"). Like Jung, Hillman is critical of the westernized Oriental ways of liberation because in their determination to attain the "peaks" (Maslow's "peak-experiences"), ecstatic God-likeness or God-nearness, they unduly minimize the dark and pathological side of human existence. Oriental spirituality, as it is practised in the West, represents a denial and disparagement of the actual imaginal soul.[13]

For Hillman the main issue is not between Eastern spiritual discipline and Western imagination but rather between the repressive Northern Protestantism of Europe and America, with its exaltation of 'ascension,' strength, unity and wholeness on the one hand, and on the other, the Southern and the Mediterranean emphasis on a pathologizing polytheistic imagery of the soul. In other words, the distinction between spirit and soul depends not on geographical boundaries (East-West), not on the kind of teacher or the kind of the adept, but upon the question of which "archetypal dominant" — spiritual or imaginal — is working through one's viewpoint.[14] Western distinctions have been reduced to a Cartesian framework:

> "between outer tangible reality and inner states of mind, or between body and a fuzzy conglomerate of mind, psyche, and spirit. We have lost the third, middle position which (is) the place of soul: a world of imagination, passion, fantasy . . . that is neither physical and material on the one hand, nor spiritual and abstract on the other, yet bound to them both. By having its own realm psyche has its own logic — psychology — which is neither a science of physical things nor a metaphysics of spiritual things."[15]

I take the view that imagination is the common ground of both Eastern and Western spiritualities in their most diverse manifestations insofar as their professed aim is to transcend all duality. By transcendence I do not mean going beyond duality in the direction of oneness and unity nor any other sort of 'wholing,' but rather an awareness of the essential polycentricity of life — seeing ontological value in the *absence* of 'eternal' values and principles. For I am convinced that there is no other way of being human and free.

Introduction: The Forgotten 'Third'

It is a basic tenet of Jungian thought that images do not hide a latent or essential meaning in addition to their apparent meaning. On the purely imaginal level we do not look for ulterior or concealed mysteries or immutable grounds for human experience. The truth and reality of the imaginal is created and exists in the created, in the image itself. It is precisely for this reason that there is no need to 'explain' the images of the psyche by reducing their manifest content to something lower or more basic. If reductionism is due to a lack of imagination, our approach is by definition radically non-reductionist.

The East, even in its most metaphysically lofty flights, has been practising the imaginal path to the extent that it has always refused to exclude other (including Western) ways of realization. It is only that neither the East nor the West have deemed it imperative to anchor this path explicitly in the psychic realm. If, however, we assume that the Eastern sage is capable of seeing through his "archetypal dominant" (for example, the Spirit) and is not taking it as a literal or absolute truth, then it must also be admitted that his *nirvana* is rooted in the psyche and constitutes an imaginal *nirvana*. It is also a Western *nirvana* with the proviso that the West take seriously the imaginal ground of its own spiritual tradition. Equally *Brahman-Atman* is without rational attributes, *neti, neti* ("not this, not this"), precisely because it unfolds as "this," "that," "you," "me," and so on *ad infinitum. Brahman* is also *maya-shakti*, the creative energy, and nirvana *is* samsara, this world of evanescent and confounding images (*eidola*) which make fully immanent the ultimate reality of *Brahman*. In India, mythology never ceased to support the expression of philosophical thought. Whether we see the world predominantly as *nirvana* or *samsara*, as *Brahman* or as *maya*, depends on our perspective, that is to say, on the power of imagination. Spiritualism and materialism are twin brothers and are the greatest sins (*hamartia*) against the soul.

We have in the contemporary West a quaternity of thinkers whose work represents a theoretical formulation of the im-

aginal path — a Western endeavor to advance metaphorically to the limits of the speakable. These men may be divided into two pairs: C. G. Jung-James Hillman at the psychological end of the spectrum and Owen Barfield-Ernst Cassirer at the literary-mytho-philosophical end. Each of them, from within his own field of inquiry, has singled out imagination (I am using Cassirer mainly for his philosophy of mythology) as that characteristically human talent — some have called it the divine power in men — which works toward self-transcendence and reconciliation of spirit and world. Whenever possible I shall emphasize parallels between these four thinkers and the non-dual approach of the Oriental ways.

I am not aware of any other attempt to bring together these highly creative and splendid minds. Consequently this is a tentative, synthesizing effort designed to show that when it is a question of circumambulating the imaginal megacosm of the psyche, we are already in the middle of a road that must be built as one travels. One must be road-ing. Before we embark upon this peregrination it should be helpful to point out some of the historical figures who have tried to place imagination within the range of other faculties. As it will turn out, these attempts, with the possible exception of the Romantic Movement, have all been abortive.[16]

The West almost invariably has distrusted, belittled and often denigrated the imaginative quality of human life, at best relegating it to the province of art and poetry, at worst placing it within the range of abnormal phenomena. Post-Cartesian philosophers and psychologists have either denied imagination any noetic value or regarded it as the source of error and deception. This is not to imply that the Westerner has lost or succeeded in eradicating the imaginative power of his soul: imagination survives resplendently not only in art but also in the pathetic entanglements of mundane life. My point is that Western society, while paying lip service to its artists and the assorted crowd, has excluded imaginal experience from its culturally and religiously sanctioned vision of reality. This vision may be best characterized in terms of a confluence of two

historical strands: the sunlike Apollonian Ego whose sublimations, in Horace's words, shall exalt him to the stars,[17] and the Protestant version of Hebrew monotheistic ethos. Put together, these two ideologies have produced what William Blake called "satanic selfhood" or, in Jung's terms, a "monotheism of consciousness" which assumes that human life is best lived by denying all that is not amenable to neat logical categories.

One is not surprised, therefore, to find that imagination, which by its very nature is ambiguous and polyvalent, has no place in a rigidly *mono*-theistic *uni*-verse. As Mary Watkins, one of the most discerning writers on the subject, has observed, "we live out the imagination in everything and yet we are against the very notion of it . . . And if we cannot make the continual bifurcations and dichotomies that our efforts at reason demand from us, we find or fear to find ourselves in the asylums which allow for the inability to separate and discard — but not without a most critical opinion, 'crazy.' "[18]

The classical associationist theory, including its modern offshoot, behaviorism, has banished anything that is not simply and unqualifiedly a "sensation," into a limbo labeled "imagination." Images, according to the canons of associationism, are merely repetitious and combinatory arrangements or facsimiles of sensations, supported by memory, which is itself but a repository of such images. Freudian psychoanalysis, for its part, has overlooked the momentous truth that Freud, as Hillman has put it, in choosing the Oedipus myth "told us less which myth was psyche's essence than that the *essence of the psyche is myth*, that psychology is ultimately mythology, the study of the stories of the soul."[19] Following the associationist attempt to *explain* the genesis of imagination reductively, Freudianism lumps together imagining, fantasying and hallucinating. All of these acts are regarded as varying ways of surrogate satisfaction of basic wishes stemming from the unconscious. Even the neo-Freudians, while granting imagination the doubtful dignity of "secondary autonomy" insofar as imagining and fantasying are valuable to the ego, fail to distinguish these mental events from hallucination in any definitive way.[20]

12

Introduction: The Forgotten 'Third'

Philosophical evaluations of imagination, with the exception of Immanuel Kant, concur in seeing it as secondary in significance. Imagination is usually confused with other apparently similar mental acts, such as memory, perception, and hallucination. To illustrate the ambivalent attitude of Western philosophy towards the imaginal I have selected four representative positions.

Perhaps the most typical of all is Plato's posture. On the one hand, he placed imagination on the lowest rank of mental faculties, well below discursive reasoning (*dianoia*), scientific knowledge (*episteme*) and rational intuition (*noesis*); on the other, he regarded *mythos* and "divine frenzy" as legitimate expressions of inner, extra-rational experiences. In this sense myth, insofar as it involves free exercise of a poetic or religious imagination, is for Plato the culmination of *logos;* at the very least there is an intimate link between mythical imagination and creativity. It is Aristotle, however, who has assigned imagination a distinct and important role in his theory of knowledge. In *De Anima* imagination is located between perception (*to aisthetikon*) and intellect (*nous*). What is more, sense perceptions from which all knowledge is derived, must themselves be in some way absorbed into the imaginative faculty before they can be of any value in the formation of thought. Thus, according to Aristotle, it is the image-making part of the soul which makes the work of higher processes possible: "the soul never thinks without an image." (431a 16; cf. 431b 2; 432a 8-14)

David Hume did not appreciably alter the tradition initiated by Aristotle and continued throughout the Medieval and Renaissance periods. He singled out imagination as that which reproduces impressions enabling us to think about things in their absence, to see things 'in our mind's eye.' In Hume's system imagination has the function of compelling us to believe that there are objects in the world which exist continuously and separately. However, since that is not actually the case, says Hume, imagination's role turns out to be that of the deceiver who gives us an altogether unwarranted sense of security; it

Introduction: The Forgotten 'Third'

acts like a drug without which we could not bear to inhabit the world.

We owe it to the genius of Immanuel Kant to have reinforced and extended imagination's (*Einbildungskraft*) mediating role by distinguishing between two kinds of imagination: reproductive and productive or transcendental. The workings of the reproductive imagination are subject to the law of association; as in Hume, its function is merely to solidify the chaos of sensations into an image, to stop it by creating an orderly series which the mind can contemplate. For our purposes it is most important that, according to Kant, the reproductive imagination is itself possible only because it is founded on the transcendental imagination which is said to have a constructive function.

Transcendental or productive imagination is an active, spontaneous power, a process that begins of itself and by itself, through its own internal agency and not through external causation. It is *a priori* to experience, not subsequent to it. Kant holds that this imagination gives rise to the transcendental synthesis combining purely sensory data with purely intellectual apprehension (categories of reason). Imagination is the mediatory power, the synthetic medium which orders the chaos of sensuous intuition according to certain unchanging general forms or schemata. What Kant calls "the schema" or a "sensible concept" is something which imagination produces out of itself whenever necessary and which is then applied to experience in order to render it intelligible. In words that seem to anticipate depth psychology, Kant says the schematism of our understanding (which is the same as imagination) is "a blind but indispensable function of the soul, without which we should have no knowledge whatever, but of which we are scarcely conscious."[21]

Martin Heidegger in his controversial study of Kant has suggested that Kant retreated from the primacy of imagination because he saw that its foundational function points to a ground more basic than sense and thought. It became clear to Kant that the foundation of all experience is determined by a

mysterious and unexplainable synthesis of the imaginative capacity. He recoiled from this discovery because it led to an "abyss." In the second edition of the *Critique* Kant reaffirmed the supremacy of reason thus reverting to the more traditional path of rationalism. In Heidegger's words, "not only did imagination fill him with alarm, but in the meantime [between the first and second editions] he had also come more and more under the influence of pure reason as such."[22]

According to Heidegger, Kant remains within the tradition of "forgetfulness of Being" (the forgotten "third"?): he merely transposed the subjectivism of Western metaphysics, which began with Plato and culminated in the Cartesian *cogito ergo sum*, to the transcendental level of the "I think." For all his greatness Kant's endeavor was a magnificently creative failure.[23] The subsequent history of philosophy and science in the West largely consists in an aggressive attempt to convert all things, including the psyche of psychology, into controllable objects for a subject. As Barfield has remarked, scientists who treat the human soul as a thing "fancy that, if you turn round quickly enough, you will see the back of your head in the mirror . . . They are like children thinking they can have it both ways. First they insist on cutting out awe and reverence and wisdom and substituting sophistication as the goal of knowledge; and then they talk about this method with reverence and awe . . ."[24]

Manifestly, the modern mind under the guise of objectivity experiences the same alarm which filled Kant's mind before the abyss of imagination; for since the time of Plato the imaginal has been associated with the passions and illusions of bodily senses and declared morally suspect. For the greater part of the Western rational tradition the prevailing attitude toward the imaginal has been fear — the obverse side of Blake's "satanic selfhood." Hume has encapsulated this attitude in a terse sentence: "Nothing is more dangerous to reason than the flights of the imagination."[25]

I

Western Romanticism and The East

1. Two Ways of Liberation

Kant's failure to appreciate the central position of imagination is merely symptomatic of Western philosophy's impotence in dealing 'imaginatively' with the perennial problem of dualism: subject vs. object, 'I' vs. 'not-I,' man and world, spirit and matter. Therefore we now turn to the Romantic Movement of the eighteenth and nineteenth centuries as a more grandiose framework in which to address this problem from the vertical standpoint of depth, i.e., the imaginal.[1] For it was the historical task of the English and German Romantics, under the influence of the post-Kantian idealism (Schelling, Fichte, von Schlegel, Schiller) to promote imagination to the rank of the primary creative agency of the human mind or the Self.

It must be pointed out, however, that the Romantic admiration for this newly discovered "true organon" of all knowledge and wisdom oftentimes degenerated into what Kant called *Schwärmerei* — sentimental enthusiasm. In Edward Casey's words, "imagination became a mesmeric term that meant so much in general — claims concerning its powers were often so exaggerated — that it came to mean very little in particular."[2] Romanticism justifiably rebelled against the Cartesian *cogito* as well as against the 'I' principle of the Kantian 'I think,' converting it into a Self which was held to be primordial, active and unlimited by the objective world. But this rebellion was bound to develop into irrationalism because it continued to be

negatively determined by the Cartesian version of the rational ideal. When the scientific tradition rejected the Romantic belief in the creativeness of the Self as outright nonsense, it nevertheless reappeared in an altered guise — as the resolution to subject the whole of nature to man's technological control. This is as much as saying that the Romantic Movement as a whole did not radically break with the idealist and subjectivist tradition of the West.

Probably the only major exceptions to subject-ism are Coleridge, Blake and Goethe. Long before Jung, Coleridge dissociated creative or primary imagination from simply reproductive imagination or fancy. Fancy — a mere handmaiden of perception — deals in similes and allusions, forming pleasing, whimsical or odd mental images with little consideration for their unity: it is "no other than a mode of Memory emancipated from the order of time and space."[3] Fancy produces the kind of imagery that comes into minds almost unbidden out of the impressions of the senses which memory has stored and retained. Creative imagination, on the other hand, is described by Coleridge not only as the source of art but also as the living power and prime agent of all human perception; it dissolves, diffuses in order to re-create and to unify. Creative imagination is essentially *vital*, which for Coleridge meant that it is a way of discovering a deeper truth about the world. The figure of depth suggests that the primary imagination consists in seeing the particular as somehow embodying and expressing a more universal significance, that is, a 'deeper' meaning than itself or what Shakespeare's Prospero calls "the dark backward and abysm of time." Coleridge is here acknowledging the importance of the idea of a concrete universal which is found in most metaphysical aesthetics of the eighteenth and nineteenth centuries.

It was Goethe who deliberately made the notion of a concrete universal the governing condition of his poetry. In a letter to Eckermann he declares that "every character, however peculiar it may be, and every representation, from stone all the way up to the scale of man, has certain universality; for

everything repeats itself, and there is nothing in the world that has happened only once."[4] In Goethe's view, everything in nature exists in a state of radical interpenetration. Moreover, the phenomena which manifest themselves on the surface not only interpenetrate one another, but variously reveal the perduring archetypes (*Urphänomen*) which they express and symbolize. The Goethean archetype, unlike the Platonic *eidos*, exists only in and through the particular. As Mephistopheles informs the pedantic scholar Faust, the green and golden archetype is perceived in the sensuous living world:

> Grau, treuer Freund, ist alle Theorie
> Und grün des Lebens goldner Baum.

If, however, we are looking beyond the Romantic Movement for a more empirically grounded and systematic vindication of the imaginal, it will be most rewarding to consult Jungian psychology and what may be considered its philosophical counterpart — Cassirer's philosophy of symbolic forms. In particular it is Jung's thought that, in conjunction with its most recent creative advance in the work of James Hillman on the one hand, and with Cassirer's exploration of myth and symbol on the other, points to something like *nirvana*. The word *nirvana* is taken in the literal sense of release from all dualities — a release which in the Western mode is that of imagination. Our venture into Jungian territory must be preceded, however, by an examination — with the assistance of Owen Barfield — of the imaginal as a transpersonal link between Western Romanticism and the Vedantic (non-dual) East. I have included Barfield because his study of symbol and metaphor in literature reveals the same relationship between myth and imagination that Cassirer discovered as a result of his reflection on the symbolic function of consciousness.

As we follow Barfield's subtle and searching disquisitions in the area of Western Romanticism, we cannot help recalling what came to be known as the "pious fraud," perpetrated by Christian mystics (ca. sixth century) to assure for themselves toleration within the Church. The fraud consisted in the fact that the writings which appeared at that time under the name

of Dionysius the Areopagite were later found to belong to an unknown Syrian monk who had merely signed the name of Dionysius the Areopagite (supposedly the first disciple of St. Paul in Athens) to his books to obtain a better hearing among his contemporaries. He was a neo-Platonist who had adopted Christianity and who combined the doctrines of neo-Platonic philosophy and the practice of ecstasy with the Christian doctrine. Dionysius' books entered into the tradition of the Western Church and acted as a kind of bulwark and guarantee for the mystical minority within the Church thereafter.

Let's assume now that the Romantic Movement of the nineteenth century, though innocent of any knowledge of the East, had already then stumbled upon a view of imagination that, in the contemporary work of men like Barfield, Hillman, and so on, has come to represent the nearest Western equivalent of Oriental disciplines of liberation. For the Romantics it would have been unnecessary to perpetrate a "pious fraud." But it may be necessary to repeat the Syrian monk's feat for the neo-Jungians, whose celebration of the polymorphous psyche should appear less threatening to the still largely unquestioned monistic vision of the West than a direct confrontation with the hopelessly confusing luxuriance of the Eastern imagery.

A while ago I suggested that development of imagination may be the Western way of nirvanizing. If we remember that *nirvana* is but a refined offshoot of the Hindu *advaitist* (nondual) maxim *tat twam asi* (you are that), we can explore in more detail the connection between the East and the Romantic idea of imagination.

Coleridge wrote about the creative imagination, among other things, as being the 'threshold' between self and not-self, between mind and matter, between conscious and unconscious. As he saw it, the task of genius is to apprehend "unity in multeity" of the objective world. While talent merely copies nature, genius, he claimed, creates after the fashion of nature herself, organically combining the 'I' and 'not-I,' i.e., repeating in the finite mind the eternal act of creation in the infinite I AM.[5] In a word, imagination is said to link harmoniously

("psychosomatically" is Barfield's word)[6] matter and spirit; it stands before the object and experientially, or rather imaginatively, knows "I am *that.*"

The Romantic appreciation of the imaginal realm has been adumbrated in the famous dictum of Heraclitus, the first psychologist in the Western tradition: "You could not discover the limits of soul, even if you traveled every road to do so; such is the depth of its meaning."[7] Bruno Snell, commenting on this passage, says that the principle of depth became the distinctive quality of the psyche: "In Heraclitus the image of depth is designated to throw light on the outstanding trait of the soul and its realm: that it has its own dimension, that it is not extended in space."[8] If we are to believe Heraclitus, what distinguishes the West, in its most receptive moments, is the awareness of the intermediate region of the psyche — the imaginal pneumosomatic "between."

It is clear however that imagination, conceived as a tie between the outward and the inward, has been cultivated in the East long before its emergence in the form of the Romantic Movement. It is only that the Easterner, when he became fully conscious of himself as a separate entity, was not prepared to accept the fact. The Upanishads have rendered this shattering primordial experience as follows: "The Self (*Atman*) looking around, saw nothing other than himself. First he said 'I am' . . . and he was afraid." (*Brhadaranyaka Up.* 1.4. 1-2) To the Oriental man individual consciousness did not seem to be an unqualified good as it seems to us. He chose therefore to use this questionable acquisition not to subdue and control the earth but rather as a tool, as a device for re-establishing the *status quo ante.* Thus it is not in the least unseemly or "pantheistic" for the Hindu to envision the god Krishna playing with girls in the same Garden (?) from which Adam and Eve were driven out. For the Eastern sage the attainment of liberation seems to entail *absorption* of ego-consciousness into the highest state of Pure Consciousness and Bliss (*ananda*) which Barfield contrasts with the Western impulse toward liberation by *vision.* The Eastern imagination is inclined to ignore or to minimize its con-

nection with the time of the earth. It wants to leave the earth too soon.

"Liberation by vision" is analogous to dreaming with one part of ourselves and at the same time knowing with another part that we are dreaming. We are simultaneously outside the dream and within it. Poets are visionaries and dreamers, not because they are prone to reveries or capricious and erratic fancy, but precisely because they do not lose themselves in the act of vision. Poetic or true or creative imagination, in its most sharpened Western form, is a noetic vision; it is cognitively meaningful, requiring the maintenance and not the sacrifice, of ordinary consciousness. It is also for this reason that, to the Westerner, Krishna's sporting with girls in Paradise, though certainly a play of cosmic proportions, should seem too placid if not flagrantly wicked (Adam had only one playmate). The Eastern man, in his relentless quest for perfect freedom, has almost succeeded in circumventing history.

In the West imagination is inseparable from what William Blake — the greatest visionary of all Romantics — called "double vision," the ability to perceive a thing in at least two ways simultaneously. When Blake looked at the sun, he saw not only "a round thing somewhat like a guinea" but also "an immeasurable Company of the Heavenly Host crying Holy, Holy, Holy is the Lord God Almighty."[9] In non-poetic words, man is not limited to the passive reception and retention of sense data; his perception and his powers of imagination extend far beyond the compass of nature.

2. Imagination and Metaphor

At this point we may distinguish two aspects or levels of imagination. On one level imagination is necessary, as Aristotle, Hume and Kant suggested, to tidy up the chaos of sense experience; we must use imagination to apply concepts and to ascribe meanings to the objects which spring up around us as soon as we are conscious. At a different level imagination is indispensable if we are to approach the objects of perception as

'symbolizing' something other than themselves. We may use imagination to render our experience unfamiliar and mysterious, to untidy the order created at the first level.

The first level also coincides with the ordinary logical use of language which presupposes that the meanings of the words it employs are constant. But, as Barfield observes, the logical or discursive use of language can never add any meaning to it, because the conclusion of a syllogism is impicitly contained in the premises. Life however is not as logical and immutably clear-cut as a syllogism.

> Every man, certainly every original man has something new to say, something new to mean. Yet if he wants to express that meaning [. . .] he must use language — a vehicle which presupposes that he must either mean what was meant before or talk nonsense.

An extended or imaginative use of language implies that "we must talk what is nonsense on the face of it, but in such a way that the recipient may have the new meaning suggested to him."[10] This is the way of metaphor. Metaphor, says Barfield, involves a tension between two ostensibly incompatible meanings, reflecting a deeper tension within ourselves —

> a tension between that part of ourselves which experiences the incompatibilities as a mysterious unity and that part which remains well able to appreciate their duality and their incompatibility. Without the former metaphor is nonsense language, but without the latter it is not even language.[11]

In sum, imagination, in addition to its commonly accepted reproductive function, has the uncanny ability to see into the inner life of things and to assure us that there is more in our experience of the world than meets the unreflecting eye; that, from quite a sober point of view, there is, as Wordsworth said, salvation from a "universe of death" (*The Prelude*). In Mary Warnock's phrasing, it is a sense, a premonition that "there is always more to experience, and more *in* what we experience than we can predict."[12]

Barfield extends the range of imagination even further by suggesting that it makes possible not only a figurative or metaphorical use of language, but also the experience of what we call matter as an epiphany of spirit. It is really the same as in

language. For example, when we see the body of a fellow being and hear his voice, we may add the various components of his behavior and then draw the conclusion that this particular conglomeration of transformed groceries is man (behaviorism has its source right here — in a lack or in a denial of imagination). Note however that even the word "man," on this purely mechanistic level of perception, is but an arbitrarily attached label to a 'something' which, if we are consistent in our denial of imagination, should never evoke in us any feelings of commiseration, disgust or admiration. But then we may also proceed by perceiving the body and the countenance of a fellow being as a material picture or image of 'something' spiritual. In fact, it is possible to look at nature as a whole in this way: not merely as matter but also physiognomically and imaginatively, as an expression. Matter can be perceived as the indispensable background of the spirit or, in Barfield's words, as "the *occasion* of spirit or, at all events, the *occasion* of the spirit's awareness of itself as spirit."[13]

Accordingly, when it is glibly proffered that imagination is creative, this should mean that it establishes a peculiar kind of *relation* between matter and spirit — a relation in which neither matter nor spirit is obliterated, but rather brought together, fused into a new whole producing ever and anon new wholes, new configurations of images in art, poetry, religion and science. In due course we should be led to the inescapable conclusion that imagination must be at work in the so-called physical nature as well.

Barfield is convinced that the great discovery made by the poets and the philosophers of the Romantic Movement was that the exercise of the imaginal capacity is "the only way in which we can really begin to have to do with the spirit." What Barfield means here is that we exist "as autonomous, self-conscious individual spirits, as free beings" not by disregarding the gap between matter and spirit (the danger in westernized Orientalism), but by consciously and lucidly depending on it. For imagination lives in the gap, in the middle, suspended "as a rainbow spanning the two precipices and linking them har-

moniously together."[14] A life within the spectrum of imagina-
tion avoids spending itself in unrestrained sensuality
(materialism — vulgar and philosophical) or in the useless
heroics of a muddle-headed spiritualism. It is rather, to use the
portmanteau term, a psychosomatic activity or, as the Buddha
who is also known as the Great Physician would have it, a life
of *nirvana*.

3. Toward a New Concept of Myth

In our move toward the Jungian *cum* Cassirer conception
of the mythical psyche we must pause to amend, at least provi-
sionally, the widespread assumption that early man projected
into nature his own ideas of souls, ghosts and ancestral spirits
which he had fashioned out of his private dreams, hallucina-
tions or cataleptic states. It is necessary to lay to rest this
nineteenth-century intellectualistic view of the genesis of myth
(Tylor, Lang, Frazer) if only because it is easily confused with
the Romantic notion of the imaginal as the realm of confluence
between matter and spirit. The result of such confusion is that
the imaginal realm is transmogrified into a nebulous modern
version of the primitive's "mystic participation" in nature.

The expression "mystic participation" was coined by the
French sociologist and philosopher L. Lévy-Bruhl (died 1939)
to characterize the "supernatural" orientation of the so-called
primitive mentality which according to him is derived from col-
lective representations manifested in typical, native social
culture. These representations are "prelogical," involving "ob-
jects and beings . . . in a network of mystical participations and
exclusions."[15] The word "prelogical" does not mean that
primitives are incapable of thinking correctly, but merely that
most of their beliefs are incompatible with the principles of
scientific and Aristotelian logic. Lévy-Bruhl does not hold that
"logical principles are foreign to the minds of primitives . . .
Prelogical does not mean alogical or anti-logical. Prelogical, ap-
plied to primitive mentality, means simply that it does not go
out of its way, as we do, to avoid contradiction."[16]

The principal weakness in Lévy-Bruhl's theory is that he made too strong a contrast between the primitive and the civilized, making them out to be different not just in degree, but in quality. According to Evans-Pritchard, Lévy-Bruhl, toward the end of his life, admitted that there may be a substratum of "primitiveness" in every person. In this he concurred with those anthropologists who recognize that "it is not so much a question of primitive mentality as the relation of two types of thought to each other in any society, whether primitive or civilized, a problem of levels of thought and experience."[17] To some extent Cassirer, too, because of his dependence on neo-Kantian philosophy, seems to share this view. Our point, however, will be that not only is there a substratum of mythical mentality *in* every person, but that mythical or archetypal images constitute the very essence of psychic life, that they *are* the psyche. Lévy-Bruhl came close to this realization (which also explains Jung's frequent references to *participation mystique*) but he could not fully appreciate it because he was dominated, as were almost all writers of the period, by the notions of evolution and inevitable progress.

Arguing against the nineteenth-century evolutionistic fantasy, Barfield suggests that the picture of the primitive man as "always projecting his insides onto something or other," i.e., as animating a dead world with arbitrarily concocted shapes of monstrous or benevolent beings, must be reversed to say that "it was not man who made the myths but myths or the archetypal substance they reveal, which made man."[18] For quite possibly the primitive had no 'insides' to begin with. Perhaps, says Barfield, instead of being a *camera obscura* (something like a box with one single, very small aperture), he was an Aeolian harp or wind harp. Now this image of the harp, on whose strings wind could be made to produce harmonious sounds, had a very special fascination for the Romantics. For example, it provided Shelley with the idea of a "Power which visits with its breath our silent chords at will."[19] Conceivably it is this Power — call it the Collective Unconscious or the Id — which breathes through the harp-strings of individual brains

and nerves and fluids, producing not only poetry but also the everpresent and luxuriant imagery of myth.

What I am trying to say here is that originally man is not an independent subject confronting an objective, alien world, but rather that the so-called subjectivity, ego, the "inner sanctum" and so on, emerges from a common ground, embracing both man and nature. Indeed the very words "subject" and "subjective," which today have come to mean "the mind only," "the personal," and even "illusory" or "fanciful," had the meaning of "pertaining to the essence or reality of a thing; real, essential." (*Oxford English Dictionary*) It is therefore not wide of the mark to suggest that nature too has an 'inside,' even though the kind of super-individual wisdom which is at work in nature may not be accessible to the Cartesian or semanticist mode of ratiocination.

In this wider context, our subjectivity, soul or consciousness, apart from the philosophical and theological accretions of meaning that these words carry, can be seen, in Barfield's scheme of things, as a "form of consciousness that has contracted from the periphery into individual centers." Then it should be also clear that

> the task of *Homo sapiens*, when he first appeared as a physical form on earth, was not to evolve a faculty of thought somehow out of nothing, but to transfer the unfree wisdom, which he experienced through his organism as given meaning, into the free subjectivity.[20]

Needless to say, the process of contraction from the periphery — that circumference which is nowhere and whose center is everywhere[21] — is also alienation of man from the Source, from the depth of psychic existence; a continuing fall which could not have been arrested had he not been able to preserve more or less intact the power of imagination. For it is precisely the role of imagination to "coadunate" (Coleridge's term) again and again the estranged subjectivity, the lonely Promethean self with its heavenly or, for that matter, earthly origin. But this transaction involves a most intricate *volte-face*. A man of imagination is not interested in relapsing into some primal, undifferentiated condition. Neither can the fusion of the inner and

the outer take place by a divine *fiat* or by a decision of intellect or will or any other *single* agency. The unity is re-established only from within that imaginal threshold by means of which the 'Thou' (of the ancient Hindu *Tat twam asi*) projects or rather retrojects — only in a more intensified and condensed form — the same wind-spirit by which it is aboriginally illumined.

We could also say that the function of imagination is to make palpable the fact that matter in its subjective (*expressive*) aspect is spirit and the spirit, regarded objectively, is the material world. In the end the same spirit which on the periphery, i.e., unconsciously, creates the world of objects, of actual mountains and trees, works in the artist to create the poem or the painting — only now in harmony with the "peripheral" (but by no means secondary) unconscious. In Schelling's genial phrase, "the objective world is only the original, still unconscious, poetry of the spirit."[22]

There is a passage in Barfield's work in which he draws an explicit parallel between his own endeavor and that of Cassirer. Cassirer, says Barfield, has shown

> how the history of human consciousness was not a progress from an initial condition of blank darkness toward wider and wider consciousness of a preexistent world, but a gradual extrication of a small, but growing and increasingly clear and self-determined focus of inner human experience from a dreamlike state of virtual identity with the life of the body and of its environment. Self-consciousness emerged from mere consciousness."[23]

In our opinion, Barfield's last sentence, on the face of it, represents a recognition of what Orientals have always meant by Pure Consciousness (*ananda, Brahman-Atman, nirvana-samsara*) — for Cassirer and Jung *terra incognita* which neither of them cared to explore. But of that later. At this stage we are simply saying that man started his career on earth not as an unconcerned onlooker facing a separate, unintelligible world about which he subsequently invented all manner of myth, but that he had to draw, to extricate his self-consciousness, out of the world of his experience; he found himself through the intercourse with the not-self.

We are considering here the phenomenon of imagination at

II

Imagination in Jung and Hillman

1. Soul and Imagination

In Jungian psychology "soul" has an objective or collective aspect which shows itself in our capacity to conceive, imagine, behave and be moved according to fundamental patterns called "archetypes." The empirical knowledge of archetypes is derived mainly from philosophy, ethnology, the arts, religion and mythology because Jung believes that these fields contain the most adequate formulations of the objective or transpersonal psyche.

Jungians, including Hillman, use the words "soul" and "psyche" most of the time interchangeably: they are not meant to be scientific terms or concepts but symbols. The soul, according to Hillman, *"is a deliberately ambiguous concept resisting all definition in the same manner as do all ultimate symbols which provide the root metaphors for the systems of human thought.*[1] Other words can be used to amplify the meaning of soul: heart, life, warmth, humanness, personality, purpose, emotion, etc. A soul may be said to be "troubled," "dismembered," "immortal," "spiritual," "lost," "innocent," "inspired." Essentially, by soul Hillman means

> the imaginative possibility in our natures, the experiencing through reflective speculation, dream, image and *fantasy* — that mode which recognizes all realities as primarily symbolic or metaphorical.[2]

The psychologist's aim is to delimit the nature of psychic reality per se, as distinct from mental contents, acts of behavior, at-

titudes, etc. This, in turn, would lead to a conception of the 'inner' and the 'subjective' in which these words do not necessarily refer to a "something" inside the body or the head.

Academic psychology, in its eagerness to be as scientific as physics, has devoted all its energies not to understand but to *explain* the soul from the viewpoint of natural sciences. In this way the soul has been exorcised from the only field which is traditionally dedicated to its study; it has been explained away, reductivized. As re-visioned by Hillman, psychology would be a search for the *logos* of the soul; a *logos* which has no single definition — Apollonian or Christian or whatever — but is rather, as in Heraclitus, a flow similar to fire. Logos is "the insighting power of mind to create a cosmos and give sense to it. It is an old word for the worse word, consciousness."[3]

According to Hillman, psychology cannot be a science of either physical or spiritual things, but a perspective, a special, psychic viewpoint that precedes all other branches of knowledge. The psychological perspective is prior because it is present in everything human beings do, feel, and think. All human reality, whether economic, social, religious, physical, is derived from psychic images. But precisely in its capacity as a perspective that sees through all our states and activities, the soul cannot itself become an object of knowledge, "another visibility." As the connecting link or the place between intellectual opposites (mind and matter, reason and emotion, the Apollonian and the Dionysian) the soul is never identical with the terms it connects. Like the Knight Errant whose home is the ceaselessly blowing spirit, the soul cannot settle or conform because it is driven to reform, reformulate and unsettle all forms.[4]

In Hillman's view, the historical importance of Jung lies in the fact that he resuscitated images. By initiating a return to the soul and its spontaneous image-making, Jung reversed the process that in 787 at the Council of Nicea had depotentiated images and in 868 at the Council of Constantinople had reduced the soul to the rational spirit. Hillman maintains that from the psychological point of view, the Nicean distinction between

adoration and veneration of images, must be seen as a victory of the Iconoclasts. In choosing to treat images as representations and illustrations (allegories) rather than as actual presences of the divine or the numinous, the Fathers foreshadowed the Kantian dichotomy between the noumenal and the phenomenal.[5] Thus when Jungians today speak of archetypal images as unknowable and transcendent realities, they are harking back not only to Kant and to Protestant Iconoclasts but to Nicea; for it was then and there that a pattern was provided for regarding the sun-like Apollonian spirit and the masculine ego as more important than the concrete and feminine psychology of imagination. Significantly it was the Virgin Mary who figured as the bone of contention at the Council, convoked by the Empress Irene in the name of the imagist parties.

The Jungian psyche is no longer based on matter or the brain or on mind, intellect or metaphysics, but on soul — on *esse in anima* as a third reality *between* the *esse in intellectu* (the mind, the idea) and *esse in re* (the matter, the thing). In the psyche, idea and thing come together and are held in balance. The psychic reality (*tertium quid*) is the creative realm of emotions, fantasies, moods, visions and dreams and its language is that of images, metaphors and symbols. According to Jung, the autonomous activity of the psyche is a continually creative process. "The psyche creates reality every day." "Every psychic process is an image and an imagining."[6]

In an attempt to extrapolate and deepen the Jungian insight into the essential nature of the psyche, Hillman adopts what he calls an attitude of "radical relativism," implying that human nature is primarily imaginal and polymorphous. Our "most natural drives," he insists, "are non-natural, and the most instinctively concrete of our experiences is imaginal. It is as if human existence, even at its basic vital level, is a metaphor."[7] Images are even prior to the world of symbols which in orthodox Jungianism have become proxies for concepts. In the beginning is *poesis* — the making of soul through imagination and metaphor. We can get to the specifically and ontologically

\-thing" at the center of our being, only by mov-
poetic mode and by using poetic tools.[8] Only
\ttuned to our essential "no-thing-ness". In all
⌣ at nothing less than an 'imaginal reduction';
⌐ating, by circuitous description (*circumambulatio*) that
⌐ehind scientific empiricism (the 'facts' of science, 'pure'
thought and 'objective' observations) lies a world of separate
primordial reality — the imaginal world. Images are the basic
givens of all psychic life and the privileged mode of access to
the knowledge of the soul.[9] Radical relativism is therefore
nothing more alarming than imaginal relativism.

It is not difficult to find support for Hillman's imaginal reduc-
tion in the writings of Jung himself. According to Jung, im-
agination underlies all perceptual and cognitive processes.
From an epistemological point of view, images are the only
reality we apprehend directly: everything we know is transmit-
ted through psychic images. Thus

> psychic existence is the only category of existence of which we have
> *immediate* knowledge, since nothing can be known unless it first ap-
> pears as a psychic image . . . To the extent that the world does not
> assume the form of a psychic image, it is virtually non-existent.[10]

In order to dramatize and to bring Jung's position to its logical
completion, Hillman boldly states that the soul itself is a fantasy
image: "We are always in one or another archetypal configura-
tion, one or another fantasy, including the fantasy of the soul
and the fantasy of the spirit."[11] Fantasy images are the fun-
damental facts of human experience and it is from the stuff of
these images that we create our world, our 'reality.'

> To live psychologically means to imagine things . . . To be in soul is
> to experience the fantasy in all realities and the basic reality of fan-
> tasy . . . In the beginning is the image: first imagination then percep-
> tion: first fantasy then reality . . . Man is primarily an imagemaker and
> our psychic substance consists of images: our existence is imagina-
> tion. We are indeed such stuff as dreams are made on.[12]

To Jung the imaginal soul is the "mother of all possibilities"
joining together the inner and the outer worlds in a living
union. Indeed the soul has all the earmarks of the Hindu
Maya-Shakti — the creative energy of *Brahman*, the lifegiving

daemon who entangles man's consciousness with the world, conjuring up a delusory world by her dancing. The soul is the "spinning woman," "the great illusionist"; the seductress who draws us into life's frightful paradoxes and ambivalences. Like Eve in the Garden of Eden who could not rest content until she had convinced Adam of the goodness of the forbidden apple, the soul is "full of snares and traps, in order that man should fall, should reach the earth, entangle himself, and stay caught, so that life should be lived."[13]

Let us now ask: what is an image more soberly considered? What do the images of the soul 'mean?' Is there anything behind or above the soul's imagery? A Void? Nirvana? A Script?

2. Image and Meaning

It is essential to understand that in Jungian psychology the word "image" is not equivalent to memory or after-image or a reflection of an object or a perception. The term is derived from poetic usage and stands for fantasy image which is related only indirectly to the perception of an external object. An image is a homogeneous product with a meaning of its own, a "condensed expression of the psychic situation as a whole." As a rule images express only those unconscious contents which are momentarily constellated, i.e., brought into consciousness. "The image is an expression of the *unconscious as well as the conscious* situation of the moment."[14]

I can best clarify Jung's attitude toward images by contrasting it with that of traditional religion on the one hand, and of psychoanalysis on the other. In the world of organized religions the tendency to suppress or at least to regulate individual symbol-formation has led to paralysis of fantasy. In every closed system of religion unconscious psychic processes (the *numinosa*) are channelled through ritual and sets of symbols which gradually become formalized to such an extent that the energy of the original experience is obliterated behind the protective walls of symbolism. The unconscious *numen*

assumes the form of universally binding, stereotyped symbolic concepts, supplying final information about the "last things" and the world beyond reason's ken. The inner revelations that flow from the unconscious of the founder are declared to be universally valid and replace the individual fantasies which become otiose and worthless if not heretical.[15]

At the other end of the spectrum, Freudian psychoanalysis assumes that it can see behind the image (or symbol) to its 'real' or latent meaning which is disguised by the apparent meaning of the image. Images and symbols are but signs of repressed and mainly sexual content. To this theory Freud was apparently prepared to sacrifice the values of civilization, "to see in the pearl nothing but a disease of the oyster, to reduce art to terms of sexual fantasy, as one might reduce a picture to its component of pigment and canvas."[16] On a more basic level, Freudianism is wedded to the dualistic premise that "reality" stands apart from the mode of its manifestation or that we are separated from it by our delusions, phobias and neuroses.

The Jungian position, for all its complexity and ambivalence, seems to be closer to the way in which imagination is treated in the East. The Eastern attitude toward images is embodied in the Taoistic principle of action through non-action (*wu-wei*). Non-action (a kind of dynamic and highly alert attentiveness), applied to the imaginal realm, is designed to prevent the practitioner from becoming entangled in the materiality of the image. For example, in the Eastern systems of meditation one is advised to watch the psycho-mental flux without interfering with it or getting attached to its content. The crux of the matter is that the individual must renounce the inbred urge to control what is happening "just so" or "thusly."

In Jung's opinion, the Eastern way, far from being an indictment of images, represents a relation to the imaginal that is superior to our rationalistic disavowal of images.

> It must stir a sympathetic chord in the enlightened European when it is said in the *Hui Ming Ching* that 'shapes formed from the fire of the spirit are only empty colors and forms.' That sounds quite European and seems to suit our reason excellently. We, indeed, think we can

flatter ourselves at having reached such a pinnacle of clarity because such phantoms of gods seem to have been left far behind. But what we have left behind are only verbal spectres, not the psychic facts that were responsible for the birth of gods.[17]

In contrast to the Freudian approach, Jung gave attention to the images in their own being. For example, he considers the dream imagery not so much as created by the censor to disguise the wishes of the unconscious, but as fully meaningful in its *manifest* content. Elaborating on this stance, archetypal psychology regards the image as "an irreducible and complete union of form and content . . . Image is both the content of a structure and the structure of a content."[18] The inseparability of the image and its content is described by Jung in these words:

Image and meaning are identical; and as the first takes shape, so the latter becomes clear. Actually, the pattern needs no interpretation: it portrays its own meaning.[19]

Hillman suggests that the first rule in psychotherapy should be: " 'stick to the image' (Lopez-Pderaza) in its presentation" because "an image is complete just as it presents itself. (It can be elaborated and deepened by working on it, but to begin with it is all there; *wholeness right in the image*.)"[20] Speaking about dream analysis Hillman recommends the Koan method of Zen:

Each time you say what an image means, you get your face slapped . . . The dream becomes a Koan . . . If you literalize a meaning, 'interpret' a dream, you are off the track, lost your Koan. (For the dream is the thing, not what it means.)[21]

Most people are ignorant of this art of letting things happen, of action in non-action, letting go of oneself, because consciousness is forever interfering, correcting and negating and never leaving the simple growth of psychic processes alone. Aldous Huxley has given one of the most perceptive descriptions of the state which results from a continuous practice of such an attitude. It exists

on a knife-edge between the carelessness of the average sensual man and the strained overeagerness of the zealot for salvation. To achieve it, one must walk delicately, and to maintain it, one must learn to combine the most intense alertness with a tranquil and self-denying passivity, the most indomitable determination with a perfect submission to the leadings of the spirit.[22]

Ultimately one acquires complete liberty of spirit: if you want to go, go; if you want to sit, sit; if you are hungry, eat, etc. This sort of spiritual freedom, which is only possible in partnership with the soul, is also connected with the Taoist idea that the good man is spontaneously obedient to Heaven: he can act in accordance with the desires of the heart without breaking the law. Jung in his autobiography formulates this state of affairs as

> an affirmation of things as they are: an unconditional 'yes' to that which is, without subjective protests — acceptance of the conditions of existence as I see them and understand them, acceptance of my own nature, as I happen to be.[23]

The Jungian attitude is also similar to that of medieval alchemists who repeatedly warned against confusion between daydreams (a form of sleepy wakefulness; madman's cornerstone according to Paracelsus) and creative imagination. In alchemy *imaginationes* are not immaterial phantoms or nonsense but a sort of "subtle body" of psychoïd nature, forming an intermediary realm between mind and matter and blending both in an indissoluble unity. To the alchemists the soul is only partly identical with our empirical consciousness. As "the vice-regent of God" the soul "imagines many things of the utmost profundity . . . outside the body. . . . the soul . . . has absolute and independent power [*absolutam et separatam potestatem*] to do other things [*alia facere*] than those the body can grasp."[24]

Henry Corbin, arguing against the equation of "imaginary" with "unreal," emphasizes that in the Islamic tradition, the world of the image, the *mundus imaginalis*, is a primordial phenomenon (*Urphänomen*) situated as an intermediary between the world of the senses and the intelligible world. The mode of being of this world constitutes its own "matter"; it "is" exactly in the way in which it appears. The comparison, regularly used by the Arabic authors, is the mode in which images appear and subsist in a mirror. "The material substance of the mirror . . . is not the substance of the Image . . . The substance [of the Image] is simply the 'place of its appearance.' "[25] In terms of archetypal psychology, the *mundus*

imaginalis of alchemy and Islam is the realm of psychic reality identical with the images contained therein. For the images are not in the psyche as in a container but *are* the psyche. In other words, images mirror the psyche just as it is — as constantly imagining. The 'place' of the psyche is identical with the 'place' of its imaging — and it is "irreplaceable!"

That we find ourselves here on a more aboriginal level of consciousness is indicated by the fact that the primitive whose conscious mind is not fully differentiated from other functions (willing, feeling) would not say "I think a thought" but rather "It thinks me"; thoughts simply *appear*. As we shall see in due course, these thoughts are the first mythical images, which in Cassirer's philosophy account for the common origin of myth and language. Eventually, the unitary vision of mythical imagination is dichotomized into the self and the world. To recapture this vision an art is needed, the artless art of watching images in the psyche's mirror.

It is an art of being fully attentive and at the same time fully relaxed — one of the hardest possible things for modern man. For in the end it involves relativization, decalcification of the Apollonian and the heroic ego or, more exactly, a separation of our awareness from the imperial ego by creating a vantage point from which the ego too can be seen as an image among other images. In our ordinary states of wakefulness we act as if we are the center of all that is to be perceived; we appear distinct from the circle of images around us. When, however, the ego is perceived as an image among other images, it recovers its predestined place on the circumference of the circle. In Mary Watkins' words,

> Once our awareness has succeeded in establishing itself independently from our egos ... the change in perspective could be likened to the one which occurred when people realized the earth was not the center of the universe, or that humans were not the first, and thereby most important creation.[26]

3. Archetypes and the Mythical Psyche

The process of differentiation of human consciousness has

been accompanied by a steady movement away from the immediacy of mythical imagination (Lévy-Bruhl's *participation mystique*) toward symbolic representation. In their new role as symbols, images are no longer "presences of divine power" but re-presentations of something else, of an idea, or instinct or Power Drive, or Great Mother. The modern Christian may piously nod that the doctrine about Heaven is a symbolic teaching but then he wants to know anyway: is there an afterlife or not! We have ascribed to imagination interpretative or symbolic meanings and thus have depotentiated the power of imagination.[27]

In spite of this process of deracination and flattening of images, the psychic facts which are responsible for the birth of imaginal gods and demons have not disappeared. Jung speaks from his clinical experience when he says that we are still possessed by autonomous psychic factors:

> Today they are called phobias, obsessions, and so forth; in a word, neurotic symptoms. The gods have become diseases; Zeus no longer rules the Olympus but the solar plexus, and produces curious specimens for the doctor's consulting room, or disorders the brains of politicians and journalists who unwittingly let loose psychic epidemics on the world.[28]

It is conceivable however that, as Barfield intimates, the rejection or disruption of the original *participation mystique* may give rise to a new kind of participation in which images are liberated.[29] Hillman, for his part, has declared that "the real revolution going on in the individual soul is . . . a struggle for a wholly new (yet most ancient and religious) experience of reality."[30]

I suggest that a new experience of reality (a Western nirvana) has been made possible through Jung's rehabilitation of the mythical or archetypal dimension of the psyche, leading to the realization that images, in their liberated mode, are themselves embodiments of meaning; that they mean what they are and are what they mean. It is possible, in other words, that a truly meaningful life has no meaning "*in*" it. Perhaps it is the case that meaning, like a poem, is something to be created out of "no-thing" and that it exists only in the created and while it is

created. "Radical relativism" also calls for radical freedom — freedom rooted in the necessity of imagination.

The importance of archetypal psychology is that it has chosen the path of watchful attention to the imaginal realm, giving, in Hillman's words, "the psyche a chance to move out of the consulting room"[31] — a chance, that is to say, to be yoked (in the Yogic sense of union) to its archaic, emotional and creative core. In moving beyond the personal and back into the unknown, archetypal ground of all life, psychology only follows the tradition of classical and archaic peoples who solved the problems of the psyche not through personal relationships (abreactive encounters, humanizing) but through the reverse: "connecting them to impersonal dominants"[32] and providing for the psyche "*impersonal* satisfaction."[33]

It was one of Jung's discoveries that the autonomous activity of the psyche (collective unconscious) is the source of myths, fairy tales and specific forms of religious belief and rituals. Myths are dramatic, personified descriptions of a non-human or quasi-human realm of tragical, monstrous, fantastic figures which are beyond the grasp of the conscious mind. These figures constitute the very basis, the *prima materia*, of psychic life. We would be deluded, says Jung, in assuming that these demons, ogres and gods are inventions or fancies of a vagrant mind. Myths are *not invented* by a primitive untutored mentality, but *experienced*. They are fundamental, real structures, *prior to any attempt to project them*. "Instead of deriving [the mythical] figures from our psychic conditions, we must derive our psychic conditions from these figures."[34]

Expanding on this central insight Jung says:

> Myths are original revelations of the preconscious psyche, involuntary statements about unconscious psychic ... processes ... A tribe's mythology is its living religion, whose loss is always and everywhere, even among the civilized, a moral catastrophe.[35]

At bottom our psyche is inhabited by a multitude of mythical persons whose fictional character consists only in that they are *more* than personal and human. In Hillman's words,

> we can never be certain whether we imagine them or they imagine

us . . . All we know is that we seem unable to imagine without them; they are preconditions of our imagination. If we invent them, then we invent them according to the patterns they lay down.[36]

The technical word for these organs or "impersonal dominants" of the deeper psyche is "archetype" — "the most ontologically fundamental of all Jung's psychological concepts."[37] "Archetype" refers to a principle or agency which organizes and structures psychic imagery into specific patterns or motifs (mythologemes) and constellations of persons in action (mythemes). Our conscious images are archetypal when they possess an archaic content or when they are primarily derived from mythological motifs. Archetypes can also be described as "partial personalities" appearing in myth, art, literature, and religion the world over, as well as in dreams, family roles, personal emotions and pathologies. We encounter them in the products of human imagination, from religious dogma to delusional beliefs, from the sublimest art to a hallucinatory psychosis. They are stances we assume when one or another of them dominates; viewpoints that rule our ideas and feelings about the world or about ourselves. In Jungian psychology archetypes are arranged under such names as shadow, *persona*, ego (hero), *anima, animus, puer* (eternal youth), *senex* (Old Wise Man), trickster, Great Mother, healer, Self.[38]

4. The 'Unknown' Archetype and Image

Jung has often stressed that archetypes in themselves are unknowable and irrepresentable (noumenal); that they exist as *a priori* 'types' in the collective unconscious and thus beyond individual birth and death. At times he compares archetypal structures to Kant's table of *a priori* categories or to Plato's *eida*.[39] It is unnecessary, however, to conclude from these and similar remarks dispersed throughout his works that Jung was unable to get rid of his Kantian presuppositions regarding the noumenon as an unknowable X. Neither should we impute to Jung the conviction that images are somehow inferior or 'mere-

ly' phenomenal in comparison with the Unknowable and hence mysterious archetypes. If, as we observed earlier, the image and its meaning are inseparable, then we have no right to construe archetypes as the primary carriers of meaning. Indeed, in the same passage where Jung speaks about "the unconscious *a priori* precipitating itself into images," he also states that over this whole procedure:

> there seems to reign a dim foreknowledge not only of the pattern, but of its meaning. Image and meaning are identical; and as the first takes shape, so the latter becomes clear . . . the pattern . . . portrays its own meaning.[40]

Admittedly Jung was philosophically so steeped in the Kantian world view that it was difficult for him to regard it in the light of his own revolution. As a neo-Jungian writer puts it, he remained a Kantian while steadily undoing Kant, by developing "an epistemological stance which renders the noumena-phenomena distinction wholly unnecessary . . . The Jungian world view *dissolved* . . . its Kantian counterpart."[41] Archetypes for Jung are not ultimate psychic "things in themselves" or metaphysically real; their 'unknowability' is only a portent of their ambiguity and the wealth of reference. Thus when Jung claims that we do not know an archetype in itself, he means that we do not know an archetype as a strictly singular entity in the Cartesian sense of certainty, but only as a whole cluster of archetypes. We know them indirectly, metaphorically, mythically, i.e., as images or metaphors.[42]

The third-generation Jungians, in an effort to avoid the old ghost of dualism in any shape and form, profess to be more interested in images, in the primacy of the imaginal life than in the "a priori organizing potential" of the archetypes. Their aim, according to Hillman, is to "get back to the unknown" that previously was located in the symbol (an outward expression of archetype) by exploring the image. Instead of asking how archetype and image are related (as two distinct events), one begins with "archetypal image." The question, for Hillman, is what happens to an image when we call it "archetypal." As we intensely watch an image or a string of images (for example, in

James Joyce's or Gertrude Stein's novels), the image amplifies
itself, "grows in worth, becomes more profound and involving";
it portrays its own meaning, becomes rich, unfathomable and
hence more archetypal.[43] As all this happens without attempt-
ing to interpret an image in terms of known, universal symbols
(images *of* the Great Mother, *of* the Hero, etc.), it is clear that
images can and should be considered apart from their symbolic
referent.

In a recent essay Hillman has made an important distinction
between symbolic and imagistic approaches. Symbolism or
symbolization is a spontaneous psychological act denoting a
"curious bunching of significance into a compressed form,
whether the form be a sensuous image, a concrete object, or an
abstract formula." In this sense symbols are abstractions from
particular images. For example, there are no swans as such, but
only Swan Lake, swans on the river Coole, or pulling
Aphrodite's chariot. A symbol can appear at all only in an im-
age; and it becomes an image when it is "particularized by
specific context, mood, or scene." It is possible to approach im-
ages via symbols, or symbols via images. If we focus on the
generality and conventionality of an image, we are looking at it
symbolically. If, on the other hand, "we examine the how of a
symbol, its particularity and peculiarness, then we are looking
at it imagistically."[44]

According to Patricia Berry, an important characteristic of
images is their simultaneity: there is no priority in an image —
all is given at once, all parts are co-relative and co-
temporaneous. "Everything is occurring while everything else
is occurring, in a different way, simultaneously." Berry also
speaks of "full democracy of the image: . . . all parts have
equal rights to be heard, belong to the body politic . . . there
are no privileged positions within the image."[45] To paraphrase
an old philosophical maxim, there is nothing in the image ex-
cept the image itself. Images simply image. (Or, as Martin
Heidegger remarked in one fretful moment — Being simply
is. What else do you expect Being to do?)

In view of these considerations Hillman suggests that it

would be more fitting to make the adjective "archetypal" stand for "the unfathomable nature of any image, even the meanest, once it dies to its everyday simple appearance." An archetypal image is thus an image with multiple implications, a rich image, "even though its surface shows only a can of beer in a Chevvie at the curb,"[46] or, to put it in Blake's terms, even when the sun looks only "somewhat like a guinea." For it is the imaginal which, as Blake would surely agree, allows us "To see a World in a Grain of Sand/And a Heaven in a Wild Flower,/Hold Infinity in the palm of your hand/And Eternity in an hour."

Granted, then, that the archetypal character of images consists in their polysemy (many-meaningness) and polyvalence, the adjective "archetypal" must be taken to point not to the noumenality of images but to the *value* of an image endowing it with the widest, richest, and deepest possible significance. In this sense archetypal psychology is a psychology of value for the paramount reason that "the archetype is wholly immanent in its image."[47]

In his relentless drive to extricate archetypal psychology from all traces of dualism, Hillman refers only to "the phenomenal archetype, that which manifests itself in images." To Hillman the Kantian noumenon which Jung occasionally associated with the archetypes, is by definition inconceivable.

> In fact whatever one does say about the archetype *per se* is a conjecture already governed by an archetypal image. This means that archetypal image precedes and determines the metaphysical hypothesis of a noumenal archetype *per se*.[48]

We must apply Occam's razor to Kant's noumenon by eliminating pseudo-explanatory entities because noumenal archetypes, like all other numinously sounding spiritual constructs, are fantasies of the imaginal psyche. The new name for Occam's razor is "imaginal reduction."

One could also say that images possess the character of necessity and inexorability because, instead of reflecting another reality, they signify and image themselves; they are necessarily what they appear to be. Image is psyche. To maintain, therefore, with Jung that human reality is primarily

psychic and that the image is the primordial and immediate presentation of this reality, means that

> there must be something unalterably necessary about images so that psychic reality, which first of all consists of images, can not be after-images of sense impressions; they are primordial, archetypal, in themselves ultimate reals, the only direct reality that the psyche experiences. As such they are shaped presences of necessity.[49]

To illustrate the point Hillman refers to an Icelandic proverb: "Every dream comes true in the way it is interpreted." This maxim expresses the very essence of "radical relativism":

> there are many truths since there are many interpretations . . . There is a God behind whatever happens . . . Nothing objective to hold to; no 'true' truth because there are many truths . . . The imagistic approach is not only relativist; it is cynical and nihilist.[50]

One must hasten to add however that this is very much the same kind of cynicism and nihilism with which an artist contemplates the so-called real life as being incomparably poorer and paltrier than his own world of fiction. The artist's world is real because it is imaginal as opposed to the imaginary and somnambulistic either/or world, the world of 'facts,' singleness of meaning and literalism. From the imaginal perspective facts are the most stubborn, delusional fictions. It is for this reason that archetypal psychology gravitates toward the field of aesthetics in the broadest sense.

The move toward aesthetics is motivated by Jung's discovery that psychic reality (*esse in anima*) is based upon fantasy images, a term which he took from poetic usage.[51] As I have already emphasized, Jung's theory of images pointed to a *poetic basis of mind* — an insight which he himself did not develop. To illustrate the radicalness of archetypal psychology's "imaginal reduction" in the post-Jungian era, Hillman speaks about the difference between the scientific and the poetic understanding of dreams. In the scientific approach dream-words are regarded as concepts or symbols that acquire their significance from their objective correlatives. In contrast, according to the poetic understanding, a dream, far from being a message containing information about something other than the dream, is "like a poem or a painting which is not about

anything, not even about the poet or the painter. [...]
artist would insist, painted lemons can and m[...]
enced without any reference to real lemons. Art is not na[...]
secondhand and one cannot paint lemons 'better' than they
paint themselves. If anything, a painted lemon or a flower is
more real in that it is something like the Goethean
Urphänomen — a concrete universal, an archetypal image. In
terms of archetypal psychology and its move toward aesthetics,
it is the same with the lemon in a dream.

> The poetic view does not need to posit an objective psyche to which
> the lemon refers and from which it is a message. Psyche is image,
> Jung said. We stick to the image because the psyche itself sticks
> there.[52]

Indeed the psyche sticks to the image precisely because it
doesn't stick anywhere in particular; because, abhorring any
kind of literalism, it loves to abide in the possible. Psyche is on-
tologically real only to the extent that it is constantly "possibiliz-
ing." For in the psychic realm possibility ranks higher than ac-
tuality.

III

Mythical Imagination —
Cassirer and Depth Psychology

1. Cassirer's Symbolic Universe and Jungian Thought

I have dwelt on Hillman's re-visioning of Jungian theory of archetypes because the concept of archetypal image, in its radicalized form, seems to provide a vantage point from which Jungian thought can be envisioned as a completion of the central project of Cassirer's *Philosophy of Symbolic Forms*. For, as we shall presently see, Cassirer's symbolic universe, for all its intellectual depth and comprehensiveness, is essentially confined to a humanly created realm of meaning from which all experience of things in their immediacy is, by definition, excluded. In the following I propose to reground, as it were, this universe within the archetypal, imaginal and polymorphous psyche thereby freeing it, on the one hand, from a merely humanistic orientation and, on the other, connecting it through psychic reality with the reality of the physical world; for when all is said and done it just may be that, as Jung has said, " 'at bottom' the psyche is simply the 'world.' "[1] But here too I shall abide by the overall intention of this essay — to indicate as clearly as possible in what ways the thought of our quaternity (Jung-Hillman-Cassirer-Barfield) is instrumental in "getting at the Eastern values from within."

We shall start with the level of mythical imagination (Cassirer

uses the words "consciousness" or "thought") and its role in the formation of the symbolisms of language, religion and art. For it is on this level that not only the agreement between Cassirer and Jung but also their need to complement each other seems to be beyond dispute. Just as Jung grants myth an inherent psychological reality instead of treating myth merely as a prelude to the emergence of reason, Cassirer holds that primitive thought has an independent logic when it is understood in terms of its own premises. On the whole, however, Cassirer's attitude toward myth appears to be ambivalent. On the one hand, he shares the view of the Romantics that myth-making is an elemental function of the human mind and an essential ingredient not only in the life of the primitive but of the modern man as well. As in Lévy-Bruhl's system, mythical thought involves faith in the supernatural and the miraculous which goes beyond conventional logic and scientific evidence. On the other hand, as a critical idealist of neo-Kantian persuasion, Cassirer is fundamentally a rationalist who is deeply suspicious of the irrational, demonic power of myth. His philosophy of myth is therefore best seen as an attempt to reconcile the extremes of rationalism and romanticism.[2] For the purposes of this essay I have extracted, hopefully with impunity, the 'romantic' aspect of Cassirer's contribution.

The differences between Jung and Cassirer stem from the fact that Cassirer does not have a psychological standpoint from which to interpret the autonomous nature of symbol formation. His approach to the symbolizing activity of man is essentially epistemological in that symbols are regarded as effective means of knowledge in relation to outer experience. Jung, however, traces symbols into the psyche and interprets them in terms of the inner functioning of the psyche: symbols arise out of the spontaneous activity of the psyche and express basic psychic processes. Jung claims to have no metaphysical assumptions other than the reality of the psyche. His theory of archetypes is a means of dealing with ideas about the universe not metaphysically but psychologically. But it is of utmost importance to recognize with Ira Progoff that: "archetypes are a

psychological but not psychologizing concept. They are used not to explain away man's beliefs about reality, but to give a deeper insight into their symbolism as primordial intuitions of life." Archetypes are psychoïd, reflecting not only views of the world, but "man's elemental contact with the world"; they "penetrate to the Adamic past and so . . . recapture the intuitions contained in the first appearance of symbol formation."[3]

To have a glimpse of the "Adamic past" we must go back to what in Cassirer's philosophy is designated as "mythical thought" — a state of consciousness which is not interested in the distinction between the "real" and the "imagined." In his penetrating discussion of myth and mythical consciousness Cassirer never refers to Jung or to depth psychology for corroborative evidence. The reason for this omission is that he had found the Freudian hypothesis of an all pervading disguised sexuality distasteful and devastating. According to Susanne Langer, Freud's emphasis on the animalian libido prevented Cassirer from recognizing that " 'the dream work' of the unconscious mental mechanisms is almost exactly the 'mythic mode' wherein an intense feeling is spontaneously expressed in an image seen in something or formed for the mind's eye by the excited imagination."[4]

We must first place Cassirer's "mythical thought" within the purview of the so-called "natural" symbolism of consciousness which is said to be prior to the creation of "arbitrary" symbols occurring in special areas of human activity. Cassirer defines man not by reference to any hypostatized metaphysical essence but by his symbolic activity in the cultural spheres of myth, religion, art and science. The entire realm of culture is a historical expression of human spirit, created and evolved by mankind in its efforts at progressive self-liberation. This means that Cassirer, having wholeheartedly accepted the Copernican revolution of Kant, regards the diverse forms of symbolism not as a direct reproduction of extraneous 'facts,' but rather as embodiments of an independent energy of human spirit (the natural symbolizing function of consciousness) through which

the simple presence of phenomena assumes a definite "meaning."[5]

From this point of view the cultural symbolic forms are "organs of reality" or configurations *toward* being:

> they are not simple copies of an existing reality but represent the main directions of [a] spiritual movement . . . by which reality is constituted for us as one and many — as a diversity of forms held together by a unity of meaning.[6]

For Cassirer the question of what reality is apart from symbolic forms, the problem of the "thing in itself" apart from its function, is false and irrelevant. The life of Reality is made up of the variety and richness of "arbitrarily" and freely created symbolic forms which constitute the highest objective truth accessible to man, a truth which is ultimately the form of his own activity. "In the totality of his own achievements the human spirit now perceives itself and reality."[7]

Cassirer's position represents a reversal of the traditional scientific and philosophical assumption that the activity of the mind consists in recording and combining sense-data. Intelligence (or "mentality") is not a product of impressions, memory and the like (*tabula rasa*) but an original factor which organizes and orders reality by means of symbols. Man is set above animals not because he possesses higher sensitivity, longer memory or an ability for quicker association but because of the power to use and manipulate symbols.

Cassirer's central thesis is that the functional link which holds together and unites all the diverse cultural forms is the symbol. Man as we know him no longer lives in a merely physical universe of hard facts, but in the midst of his imaginary emotions, in his illusions, fantasies and dreams. "He has so enveloped himself in linguistic forms, in artistic images, in mythic symbols or religious rites that he cannot see or know anything except by interposition of [the] artificial medium [of the symbol]." He has become an *animal symbolicum* living in a symbolic universe.[8]

Had Cassirer not been diverted from delving into depth psychology, he would have recognized an analogue for his

symbolic universe in the autonomous realm of the psyche where "every process is an image and an imagining." (Jung) Or as Hillman, elaborating on Jung, unfalteringly propounds:

> All consciousness depends upon fantasy images. All we know about the world, about the mind, the body, about anything whatsoever, *including the spirit* and the nature of the divine, comes through images and is organized by fantasies into one pattern or another . . . Because these patterns are archetypal, we are always in one or another archetypal configuration, one or another fantasy, including the fantasy of soul and the fantasy of spirit.[9]

When Hillman further says that all faculties of the psyche are "means of soul-making" or that the way of psychology is an "interiorizing process from visible to invisible,"[10] he is in effect stating in psychological terms what Cassirer, from the epistemological standpoint, means by symbolic consciousness as the original imaginative power of the mind or the medium through which must pass all the configurations presented in the separate branches of knowledge.[11] It is only that for Jung and Hillman, Cassirer's symbolic consciousness would be reduced to imagining and fantasy as the ultimate operative agents of the psyche.[12]

To the eternal delight of all those who are never comfortable in any doctrinal, ideological or scientific straitjacket, Hillman has created a position which is impervious to any principled criticism. For whatever may be suggested as contradicting his analysis, is nonchalantly demonstrated as just another configuration of fantasies and images perennially flowing from the psyche which is itself nothing more than a fantasy image. Having accepted as a point of departure the Jungian insight that we are not one but many, Hillman can contemplate with equanimity and non-attachment all the contending perspectives and *Weltanschauungen* as variegated ways in which the unfathomable psyche "is" in the world. All metaphysical and ontological claims are reduced to the images which they express. Thus his "reduction to the imaginal" is not a reduction to something lower or less complicated, but rather to the "extreme radix of the psyche," to the "irreducible, the essential oil, the quintessence of one's nature."[13] In this sense Hillman's

'position' is to have no entrenched positions whatsoever except for the non-position or no-thing-ness of the psyche itself. Psyche is precisely nothing in itself because it is absolutely implicated in everything.

Cassirer's nearest equivalent for psyche's "archetypal configurations" is what he calls "unconscious ideation" denoting a basic productive function of the spirit or "productive imagination" which Kant singled out as "a necessary ingredient of perception itself." Unconscious ideation (the primary imagination of Coleridge) is an act of original formation in which all our seeing and perceiving must be rooted. On this point as on many others Cassirer agrees with Goethe, who said that there is creation in the very act of seeing, that all sensuous seeing is already a "seeing with the eyes of the spirit."[14]

When, in turn, Jung correlates the organism confronting light with the structure of the eye on the one hand, and the psyche confronting the natural process with a symbolic image on the other, he too echoes Goethe's famous verse, expressing the affinity between nature and soul:

> Wäre nicht das Auge sonnenhaft
> Die Sonne könnt' es nie erblicken.
> Läg nicht in uns des Gottes eigne Kraft
> Wie könnt' uns Göttliches entzücken?

(If the eye were not of sunlike nature, it could never see the sun; if the power of the Deity itself did not lie within us, how could we take delight in the Divine?)

For according to Jung, the primordial images and symbols "arise in the depths of the body and express its materiality every bit as much as the structure of consciousness . . ." Through consciousness, the world itself speaks, because "'at bottom' the psyche is simply the 'world.'"[15]

Cassirer's concept of symbol closely parallels that of Jung. Symbols, in contrast to signs which are always part of the physical world of being, belong to the world of meaning; all symbolic relations are meaning relations. Whereas signs are fixed, conventional abbreviations for something known, a symbol is "the best possible formulation of a relatively unknown

thing which for that reason cannot be clearly represented."[16] Both Jung and Cassirer regard symbols as the intermediary field (*tertium quid*) between spirit and matter. Life and thought, nature and spirit flow through consciousness as a single stream, producing the diversity and cohesion, the richness and continuity of the symbolic forms. The mediating function of the symbol transcends the traditional opposition between the free spontaneity of the mind and the passivity of the senses: ". . . the senses and the spirit are now joined in a new form of reciprocity and correlation" since it is precisely the essential function of the human spirit to seek its fulfillment in the sensory world and to disclose itself by shaping sensible matter.[17]

The great achievement of Cassirer was that he saw the symbolizing function at work in all forms of 'objectivization' of the human spirit, on the level of discursive experience as well as in the non-scientific realms of myth, poetry, art and religion. Each of these symbolic forms "constitutes, as Goethe said, a revelation sent outward from within, a 'synthesis of world and spirit,' which truly assures us that the two are originally one."[18]

Cassirer's standpoint is anthropocentric in the widest sense of the world. "Man" includes *humanitas* — the whole system, the circle of human activities, within which he creates his own "form," the form of a symbolizing animal. Man's being is circumscribed by the sphere of his creative (symbolic) activity. But then we hear a complaint which, given the Kantian presuppositions of Cassirer's thought, could not have been avoided for long. The human spirit "more and more . . . appears to be imprisoned in its own creations . . . which cover it like a delicate and transparent, but unbreachable veil." Philosophy, dedicated as it is, to the clarity of discursive thought, cannot penetrate behind the veil to "the paradise of mysticism, the paradise of pure immediacy."[19] The world of symbolism, created by man in his attempt at self-liberation, in the end appears as no more than an immensely aggrandized, magnificently furnished castle from which the world in its sheer physicalness is forever banished — there are no exits leading toward what Hillman calls non-human or impersonal satisfac-

tions. What is missing in Cassirer is an ontology of "the third" — the psychic realm; his notion of the symbol as the intermediary between spirit and matter is more spiritual than "intermediary." He could not imagine that only the psyche can mediate without being absorbed in the mediated.

In his later writings, particularly in *An Essay on Man*, Cassirer develops a view of man which seems to go beyond that of *animal symbolicum*. Now it is in art and in artistic creation which he claims to be commensurate with the production of "pure sensuous forms" that the "paradise of pure immediacy" seems to become, in a fashion, available after all. Poets and mythmakers, says Cassirer, live in the same world and are endowed with the same power of imagination which gives every object an inner life and personal shape. There is no need for poets to look back nostalgically at the lost paradise of myth, for it is one of the greatest privileges of art that it can never lose sight of this 'divine age.' Here the source of imagination never dries up.[20]

The distinctive feature of artistic imagination is that it abolishes the opposition between the content (the latent) and the form (the manifest) because the one perfectly reflects the other. Our passions (emotions of fear, pity, horror), artistically envisaged, are no longer dark and impenetrable, but transparent. They seem to mirror the process of life itself — life as a dynamic and continuous oscillation between the opposite poles of joy and grief, hope and fear, exultation and despair. In this respect art could be seen as a condensed illustration of the Heraclitean law of *enantiodromia* which Jung has elevated into the basic principle of psychic life. In Jungian therapy psychic images, like artistic creations, embody their own meaning; they are self-revelatory.[21] Lastly, Cassirer, without referring to Jung or depth psychology, seems to be doing Jung all the same when he says that in order to discover the deeper sources of art "we must plunge into the mysteries of our unconscious life," or when he quotes Friedrich Schlegel to the effect that poetry leads us into the "ravishing confusion of fantasy, the original chaos of human nature."[22] It is only that Cassirer, because of

his lack of familiarity with depth psychology, could not perceive the unconscious also as the source of all forms of order created by the human imagination. The purposive and teleological aspect of the unconscious which Jung stresses as much as its instinctive and destructive aspect, was for Cassirer essentially a property of the symbolic *consciousness*. We must conclude therefore that in the last resort the *animal symbolicum* represents the triumph of the Apollonian spirit.

Now I maintain that the poet's dream of a 'divine age' is the animating force not only in art but also behind the endeavors of archetypal psychology. Professedly, there is an artist and mythmaker in everybody; the human psyche, we are told, produces fantasies all the time and we always act according to one or another archetypal pattern. Therefore, rather than exceeding the scope of this inquiry by a detailed discussion of Cassirer's theory of artistic creation, I should like to confine myself to his presentation of mythical thought — the area where he is at his best and most illuminating. In other words, we may catch a glimpse of "the paradise of immediacy" through an exploration of the mythical psyche which, as we saw earlier, far from being a thing of the past, is actually "the speculum" of the imaginal psyche in all its manifestations.

It must be also made clear that the symbolic universe in which, according to Cassirer, we seem to be imprisoned, is a relatively late achievement in the cultural existence of mankind. Man has passed through a long development before he acquired the consciousness of the versatility and variability of symbols.[23] As Jung has pointedly observed,

> we have to imagine a millennial process of symbol-formation which presses toward consciousness, beginning in the darkness of prehistory with primordial or archetypal images, and gradually developing and differentiating these images into conscious creations.[24]

I shall now highlight some of the significant moments of that mythical "stage" in which images have not yet been transformed into conscious creations, i.e., representational symbols. The word "stage," however, has no evolutionary implications. The "mythical stage" has rather the meaning of an actor's stage

where the play goes on without going anywhere in particular. It is the same with the psyche: the play of images just goes on — neither eternally repeating itself nor, in the fashion of Teilhard de Chardin's sublimated materialism, toward a divinization of the cosmos. In this sense the mythical stage is just as differentiated, i.e., polymorphous as any other or later stage of development. Here too we are dealing with fantasies of stages, fantasies of development and fantasies of the "primitive" whose ultimate projector is the psyche — the greatest and the deepest fantasy of them all.

2. Mythical Imagination

Cassirer's philosophy of symbolic forms is based on the maxim that the same Logos is at work within the entire range of man's symbolizing activity. The symbolic function is the common root of both the discursive (scientific and philosophical) and intuitive (artistic, mythical and religious) levels of experience. Myth as symbolic form is a distinct and original way of knowledge which must be evaluated not by norms taken from alien disciplines but in terms of its own form and structure. Susanne Langer, a disciple of Cassirer, regards the mythical mode as part of "presentational" or "non-discursive" symbolism which accounts for imagination, dream, myth and ritual and brings within the compass of "rationality" much that has been traditionally relegated to mere "emotion."[25]

Cassirer is not interested in mythology as such or in the content of myth, but rather in the type of consciousness that actually produces myths. He is therefore opposed to those who, like Tylor, Frazer or Lang, attempted to intellectualize myths by interpreting them as fumbling efforts on the part of the savage to explain nature. In agreement with Jung he holds that the "primitive mentality" does not *invent* myths, but *experiences* them. In Jung's words: "The primitive does not think; the thoughts come to him"; and he adds that we ourselves still feel certain particularly enlightening ideas as "influences," "inspirations," etc.[26] Mythis are original and involuntary revela-

tions of the pre-conscious psyche. Their function is to promote a consciousness of solidarity of all life, a unity of feeling between individuals as well as a sense of harmony with the whole of nature and life.[27]

According to Cassirer the mythical world of the primitive embodies a "unitary energy of the spirit"[28] which manifests itself in the gradual creation of a new intermediate realm of reality — the realm of the image and pure imagination. The image stands on the borderline between the merely subjective (the inside) and the merely objective (the outside). What modern scientific thought considers as the objective world 'exists' for the nascent ego only in the guise of emotions of fear, desire or horror: ". . . things 'are' for the I if they affect it emotionally. . . ." In Cassirer's opinion, this fact alone contradicts all theories which make personification and worship of certain natural objects and forces the beginning of mythical consciousness. Before the primitive begins to objectify his emotions in the form of particular well defined gods and demons, there is a phase during which the world exists for man only in *unformed feeling*. It is the stage of *first mythical images* confronting man in the shapes of elemental spirits, in the rustling of the leaves, the murmuring and roaring of the wind, in the voices of the forest, etc. These images are "the expressions of a unique stirring, a momentary tension and release, of consciousness, which will perhaps never be repeated in similar form."[29]

The mythical image does not represent the thing, but rather replaces the thing's immediate presence: it is the thing. The phenomenal and the real are fused into one, or, to put it differently, every phenomenon is always and necessarily an incarnation, a pure expression rather than representation.[30] For the primitive, therefore, our contrast between reality (essence) and appearance is meaningless: the world is fully present in the mode of its appearance. Whatever affects the mind, feeling, or will has the lineaments of a fully objective, undoubted reality. " 'To be effective' to the mythopoeic mind means the same as 'to be.' "[31]

Mythical Imagination

It has also been suggested that mythical thought functions according to the principle of *pars pro toto* (a part can stand for the whole); the image or the thing (for example, a lock of hair) is experienced as a genuine presence containing the power, the significance and efficacy of the whole (the man). The meaning of images dwells in the images themselves as life dwells in the body. It is for this reason that, in Langer's words, "mythical symbols do not even appear as symbols; they appear as holy objects or places or beings and their import is felt as an inherent power."[32]

Thus when we see the archaic man filling the world with sacred trees, rocks, ghosts or later on — with a pantheon of more or less anthropomorphic gods — we should not glibly assume that he is trying to twist reality into the categories of his own ego. Cassirer believes that it is a mistake to regard the mythical mode as a process of personification of natural forces and events. The spirits and demons of the early myth are not personifications, but objectivizations of instantaneous, fleeting, intense impressions which occupy and possess the primitive's consciousness.[33]

In myth the boundary between the personal and impersonal is fluid; there is nowhere an 'it' as a dead object, a mere thing and, conversely, what is a 'thou' can at any moment become an 'it.' "Everything is connected with everything else by invisible threads, and this connection, this universal sympathy, itself preserves a hovering, strangely impersonal character."[34] It is only gradually that the 'I' as a distinct entity emerges from this state of unformed feeling, this "society of life." But, as Cassirer hastens to add, the mythical consciousness is never completely lost or extinguished. The original potency of the myth to unify the inner and the outer, to see the universal in the particular, continues to live and to assert itself in the entire field of consciousness. For

> what constitutes the unity and totality of the human spirit is precisely that it has no absolute past; it gathers up into itself what has passed and preserves it as present.[35]

In conclusion, Cassirer is convinced that the usual an-

thropomorphic nature of the mythical process must be re-
versed: the primitive, instead of transferring his own finished
personality to the god, first discovers himself as active spiritual
principle through the figures of his gods: the human 'I' finds
himself only through a detour of the divine 'I.'[36] But again we
must insist that gods who were thus instrumental in the
emergence of the human 'I' do not vanish. They are always
present in all our doing and thinking as the imaginal and poetic
basis of our psychic structure. Gods are part of our life today
just as they were in the past and will be in the foreseeable
future, because it is through them that we can imagine the past,
present and future to begin with.

3. Re-Souling the World

Cassirer's reversal of the anthropomorphic character of the
mythical formation has found an eloquent confirmation and
radicalization from the side of archetypal psychology. In sharp
contrast to psychologists who deprecate personifying as regres-
sion to delusional or hallucinatory modes of adaptation,
Hillman uses the term to signify a basic psychological activity:
*"the spontaneous experiencing, envisioning and speaking of
the configurations of existence as psychic presences."*[37] Per-
sonifying must be distinguished from personification which is a
psychologism, implying that we create gods in our likeness or
that they are our projections.

The idea of projection or animation of dead matter (the
Cartesian *res extensa*) is based on a theological presumption
that "person" is the only carrier of soul or that "all my subjec-
tivity and all my interiority must be literally *mine*, in ownership
of my ego-personality." It is then further assumed that this
unique personality, as a result of some more or less benign
aberration, sets out to 'anthropomorphize' or 'personify' objects
of the 'outer' world. We just saw, however, that such a picture
of the primitive man is due to a misapprehension of the basic
mechanism of mythical information. In the words of the late
German mythologist, Walter F. Otto,

> there is no such thing as personification, only depersonification —
> just as there is no mythologizing [...] but only demythologizing.
> Schelling said that the question how did man ever come to God is
> senseless; there is only the question, how did man ever come away
> from God.[39]

Indeed the concept of the psyche as a polycentric field of
powers and personalities who operate in our lives, has a long
and venerable tradition. Frazer has shown that primitive man
regarded the soul as an impersonal presence with which he
could converse; moreover, he associated himself with a plurali-
ty of souls, at least four and sometimes as many as thirty. In
Frazer's words

> the divisibility of life, or . . . the plurality of souls, is an idea sug-
> gested by many familiar facts, and has commended itself to
> philosophers like Plato as well as to savages. It is only when the no-
> tion of a soul becomes a theological dogma that its unity and in-
> divisibility are insisted upon as essential. The savage, unshackled by
> dogma, is free to explain the facts of life by the assumption of as
> many souls as he thinks necessary.[40]

Hillman is convinced that psychic polycentrism and personify-
ing are not inferior, archaic forms of thinking appropriate only
to children, madmen, poets and primitives. Personifying is a
spontaneous activity of the soul, "a way of being in the world
and experiencing the world as psychological field"; "a way of
knowing what is invisible and hidden," an "epistemology of the
heart." Ultimately, says Hillman,

> we do not . . . personify at all . . . Where imagination reigns, per-
> sonifying happens. We experience it nightly, spontaneously, in
> dreams. Just as we do not create our dreams, but they *happen* to us,
> so we do not invent the persons of myth and religion: they, too, hap-
> pen to us. The persons [of the myth] present themselves as existing
> prior to any effort of ours to personify. To *mythic consciousness the
> persons of the imagination are real.*[41]

Personifying is above all a way of returning to the images in
their phenomenality which, as in mythical thought, cannot be
distinguished from what is conventionally supposed to be reali-
ty. For the hiddenness and invisibility of an image lies not in the
fact that it contains something apart from its appearance, but in
its "multiple ambiguity of meanings." As we have emphasized

on several occasions, images are exactly what they appear to be — never standing still, undefinable "except through and by their complications in each other."[42]

In Hillman's psychology a return to the imaginal implies re-souling the world, giving back soul to the world. This is not as far-fetched or merely "romantic" as it may sound. If imagining and fantasying is not just an interior process going on in our heads, but much more like "a way of being in the world," it follows that the meaning of the image cannot be derived from external events. Image and reality are not two events. The sensual qualities of an image — form, color, texture — are not copied from objects and they never replace reality as in visions or hallucinations. To put it paradoxically, images are real precisely because they do not correspond to anything in the so-called outer or objective world of our ordinary experience. In Patricia Berry's words, only perception has to do with "objective reals — what I see is real and there." In this sense hallucinations (whether physical or psychedelic) pertain to perceptions, whereas images pertain to imagination. Imaginal and perceptual are two different psychic functions. "With imagination any question of objective referent is irrelevant. The imaginal is quite real in its own way, but never *because* it corresponds to something outer."[43]

Empirical psychologies consistently confuse imagination and perception; sense-perception is employed for a whole medley of things, for hallucination, feelings, images, ideas and dreams. Empiricism attempts to turn the image and thus the soul itself into a thing, into "another visibility" forgetting that the image as a psychic phenomenon is perceivable only by the psyche itself. Hillman says, "we perceive images with the imagination, or better said, we imagine them rather than perceive them, and we cannot perceive with sense-perception the depths that are not extended in the sense world."[44]

To this we may only add that one must "stick to the image" because the imaginal comes first, not temporally but ontologically; it shows of and by itself as what it is, it images itself. Imagism in this sense is not psychologism if the latter means

converting all things into some sort of non-substantial, 'only psychological' contents, i.e., into something of a lesser status, dignity, value. "We keep from psychologism by remembering that not only is the psyche in us as a set of dynamisms, but we are in the psyche."[45]

4. Logic of the Soul

What does it mean: to be "in the psyche?" With this question we are broaching the difficult subject of the logic of imagination and of the logos of the soul. For if the soul is not identical with perception (body) or with our conceptual thinking (mind), it must, in the words of the late Evangelos Christou, have "a *logic of its own* and an experience of its own not to be seized by languages appropriate to physical phenomena on the one hand, and to mental processes on the other."[46] The task confronting archetypal psychology is to develop a "meta-psychology" which, instead of looking for its foundations in the metaphysics of the last century's sciences (Freud) or in the ontology of the early Heidegger (Daseinsanalysis), is based on psyche itself.

It cannot be emphasized too much that the reality of psychological experience is not reducible to statistics of probabilities, bio-chemical analysis or speculative metaphysics, i.e., to the reality of perception or conception. Christou uses the term "experience" in order to bring out that "indefinable more" which makes psychology an independent science. "The soul is neither the thinking, willing, wishing subject nor is it the perceiving material body, but rather the experiencing subject." In other words, it should be possible to say *"I experience and not mean that I am merely wishing, willing, thinking or perceiving."* Or again:

> In this sense of psychological factualness or reality, spirits may or may not exist. a pain may or may not be imaginary, a sensation may or may not correspond to a physical object, but all are real in the sense that they can be experienced and this experience constitutes a world in its own right.

Once psychic reality is established, the soul becomes truly the middle, containing the possibility of reunification of mind and body "into a higher and more essential unity than it has at present been possible to achieve in Western culture."[47] In turn, imagination acquires the function of the unifying "supraordinate third" (the Aristotelian excluded middle between conceptual opposites) obeying its own law — the law of interpenetration, correlation and contemporaneity.

The mediatory role of the soul is not an invention of archetypal psychology. We encounter this idea in the neo-Platonic philosophies of the Italian Renaissance, particularily in the systems of Marsilio Ficino and Giordano Bruno. Ficino is related to Plato largely by way of Plotinus, for whom psyche is the middle of three hypostases, "an intermediate station" between *nous* and *physis*.[48] In Ficino's own philosophy

> the soul is in the middle between higher and lower beings . . . Since . . . love, according to Plato's *Symposium*, is an active force that binds all things together, and since the human soul extends its thought and love to all things from the highest to the lowest, the soul becomes . . . in a sense the center of the universe. The soul is the greatest of all miracles in nature, for it combines all things, is the center of all things, and possesses the forces of all. Therefore it may be rightly called the center of nature, the middle term of all things, the bond and juncture of the universe.[49]

It seems that all philosophical doctrines about the intermediate status of the soul, including the Islamic, have originated with Plato.[50] Hillman also follows Plato when he talks of *metaxy* (the middle region) as a perspective, a viewpoint toward things rather than a thing itself. *Metaxy* is similar to what Christou means by "experience"; it is a realm of meaningness, a "function of relationship."[51] "Between us and the events, between the doer and the deed, there is a reflective moment — soul-making means differentiating this middle ground." And further: "By having its own realm psyche has its own logic — psychology — which is neither a science of physical things nor a metaphysics of spiritual things."[52]

Using a metaphor from Jung, Hillman says that soul-making refers to the " 'discriminating knowledge' that Prakriti evokes

in Purusha by dancing before him. Purusha, by the way, does not use a sword for this discriminating. He watches."[53] What is Purusha (the "absolute man" or the Self) watching? The answer must be: things as they are, i.e., things not in their literalness and facticity, but as thing-ing — interpenetrating one another, never standing still, souling.

It is especially noteworthy that, according to Hillman, the psychic world is also the world of time.[54] In his lengthy essay on "Anima," having shown that the anima archetype is very often described by Jung asexually or simply as "life," he states that it is analogous with "Maya, Shakti, Sophia, and the p'o soul" pointing to "a specific kind of life, life which projects out of itself consciousness."[55] And then we have Jung's words:

> The anima . . . is a 'factor' in a proper sense of the word. Man cannot make it; on the contrary, it is always the *a priori* element . . . in psychic life. It is something that lives of itself, that makes us live; it is a life behind consciousness that cannot be completely integrated with it, but from which, on the contrary, consciousness arises.[56]

In Hillman's opinion "anima here is not a projection but it is the projector . . ." As "the primordial carrier of the psyche, or the archetype of psyche itself"[57] anima projects consciousness and the time of the world. As we saw earlier, *Maya-Shakti* of the Hindu mythology is a cosmic principle, the power of cosmic dance (*lila*), Brahman's creation of illusion. Yet there is no antagonism between "real" and "unreal." Reality (*Brahman*) and its mundane realization (*maya*) are in essence one. There is differentiation, polymorphy but no estrangement, no tendency to deprecate the dark and terrible, sublime, all nourishing and consuming "Mother of the World."

> Brahman, sakti, the life-substance of Indian nondual philosophy, is the principle that enters, pervades, and animates the panorama and evolutions of nature, but at the same time is the animated and pervaded, entered field or matter of nature itself (*prakrti, natura naturans*); thus it both *inhabits* and is the manifested universe and all its forms.[58]

Maya-shakti is also *samsara*, the Buddhist realm of soul-making (*karma*). Somewhat like the Jungian archetype which is fully immanent in the image, *nirvana* is *samsara*.

In conclusion, the answer to our question, "What does it mean — to be in the soul?" is psycho-logical: it is to be in a re-souled or re-mythologized world — a world where there is no need for spying out "mystery" in the commonplace. Meaning and reality are fully present in the phenomena not because they hide a deeper or numinous sense requiring special or esoteric knowledge, but because they exist, always and necessarily, in a web of relationships without end. Images are always in the plural, in the state of many-ness; by their very nature they are *samsaric* which is just another (Sanskrit) word for the (Greek) "metaphoric." In a deep sense phenomena are metaphors from the moment they are divested by the soul of their literalness and are seen from the standpoint of *metaxy* — that "no-place" which is the place of imagination. It is an intriguing thought that "the Son of Man" whom William Blake called "Jesus the Imagination"[59] and who is destined to undo the work of the fall, "has nowhere to lay his head." (Matt. 8.20; Lk. 9.58)

IV

That "We Are Not Real"

1. Beyond the Heroic Ego

In Hillman's view, Jung's most important contribution lies not in the discovery of archetypes but in his radically personified formulation of them. Jung is lauded for having never deserted psyche in search of explanatory principles outside its own imaginal world. *"We are always talking about persons even at the most abstract level of discussion."* Hillman carries the psychological standpoint of Jung to its logical conclusion by proposing multiplicity of persons ("powers and principalities") as the basis of psychic existence. The purpose of this move toward personifying is "to save the *diversity and autonomy of the psyche from dominion by any single power* . . . Personifying is the soul's answer to egocentricity."

To envision human personality as polycentric means that "we are no longer single beings in the image of a single God, but always constituted by multiple parts: impish child, hero or heroine, supervising authority, asocial psychopath, and so on."[1] According to Jung, the so-called unity of consciousness is an illusion. Psyche by its very nature tends toward fragmentation and dissociation. We prefer, however, to ignore this unsettling truth because we fear imagination. Lacking any knowledge of the fragmentary and unconscious systems

we . . . pursue the cult of consciousness to the exclusion of all else. Our true religion is monotheism of consciousness, a possession by it,

coupled with a fanatical denial of the existence of fragmentary autonomous systems.[2]

Hillman's answer to "monotheism of consciousness" is a polytheistic psychology referring to the *"inherent dissociability of the psyche and the location of consciousness in multiple figures and centers."* It is important to note that a polytheistic perspective does not contradict a monotheistically centered psychic structure. Both of these positions — the rule of the ego and fragmentation — are stereotypes and must be seen as differing styles of consciousness, as fantasies of the soul. They are no more than differing value systems, patterns of fantasy.

> The Roman central ego is no more 'conscious' than are the outlandish styles of other complexes. Consciousness may be reapportioned without thereby being diminished; it may return to the bush and fields, to its polycentric roots in the complexes and their personified cores...[3]

A genial guide in this uncertain venture is Heraclitus, for whom diversification and strife are the common condition and the father of all things ("War and Zeus are the same thing.")[4] Instead of going East or proposing a new primatology, Hillman has chosen to remain within the Western tradition, since here too "psychology has no limits when it is true to the limitless soul that Heraclitus envisioned." In contrast to the Protestant-Hebrew monocentric vision, representing the path of the heroic ego and unity, the Heraclitean Greece — "an inner Greece of the mind" — offers a "wider space ... to the full range of images" and "a chance to revision our souls by means of imaginal places and persons ... We return to Greece in order to rediscover the archetypes of our mind and of our culture."[5]

It is easy to see however that the Greece of our mind, that is to say, the imaginal ground of the psyche can be also reached by a detour through the Orient. As I have already pointed out, the Eastern mind considers the shapes of our interior gods and demons as nothing more than empty colors and forms because, in Jung's words, "it has long since extracted their essence and condensed it in profound teachings." The East has taken the necessary first step by recognizing that gods and goddesses which live through our psychic structures are real

That "We Are Not Real"

powers to be reckoned with; only then has it struggled "to disentangle itself from the daemonic forces of life in order to enter into the ultimate undivided unity, the 'centre of emptiness' where 'dwells the god of utmost emptiness and life.'"

The West, having rejected fantasy as worthless subjective daydreaming, was forced to experience the return of the Olympians in the form of diseases. In Jung's opinion, Western man, instead of assuming the unreality of demons,

> ought to experience once more the reality of this illusion. He should learn to acknowledge these psychic forces anew, and not wait until his moods, nervous states and delusions make it clear in the most painful way that he is not the only master in his house.

For our dissociative tendencies (gods and goddesses) are *real* only when they are not recognized as real, but they are "unreal to the extent that consciousness detaches itself from its contents."[6] What Jung means by the illusory and unreal character of gods and goddesses is their literal unreality; psychologically, or for that matter imaginally and metaphorically, they are the only "reals." The only meaningful detachment, therefore, is the detachment from the literalness of the contents of our consciousness, not from 'life' and the world.

Following Jung's lead, Hillman claims that personifying helps place the multiple persons "out there" so that we may become "aware of distinct parts." Even if the unity (wholeness) of personality is the aim, as Jung ever so often insisted, separation must come first. Separation (*separatio* in the language of alchemists) is "a way of gaining distance" and "it offers internal detachment."[7]

This "internal detachment," however, is made possible only because the mythical persons which inhabit the psyche are themselves more than personal and human. Indeed they are fictions, not in the sense of subjective inventions of human mind, but as the "truths of the imaginal,"[8] as guiding fictions whose main function is to manifest the unreality of our 'humanistic' and 'wholing' personalities. According to Hillman, true 'wholeness' and authenticity is not in the Self (the Jungian psychological equivalent of Jehovah) but in a multidirectional psychic structure which takes nothing statically or literalistically.

71

That "We Are Not Real"

Depth psychology follows a Dionysian logic, holding that

> authenticity is in the perpetual dismemberment of being and not-
> being a self, being that is always in many parts, like a dream with a
> full cast. We all have identity crises because a single identity is a delu-
> sion of a monotheistic mind . . . Authenticity is *in* the illusion, playing
> it, seeing through it from within as we play it, like an actor who sees
> through his mask and can only see in this way.[9]

It should be clear at this juncture that awareness of the
polymorphic character of the psyche implies on Hillman's part
a wily refusal to be bound to any specific theory or doctrine
about man and the world. Archetypal psychology is not en-
gaged in any theology or philosophy of man attempting to
place him between ape and angel or dividing him between
mind and matter. The crucial distinction is that between psyche
and the human. We have already found that psyche is more
embracing than man: "Human existence is psychological
before it is anything else." In terms of logical priority, all realities
— economical, social, religious, physical — must be inferred
from psychic images or fantasy representations of a psyche.
The soul is never identical with any literal perspective; the
distinctness of the soul consists precisely in its ability to see
through all mutually opposing views, systems, positions.

The soul itself, however, is not "another visibility"; it only
sees all things and "is" entirely, unreservedly in the act of see-
ing. What we experience as our individuality (*my* emotions, *my*
temperament, *my* mannerisms) is no more or *less* than a col-
lage of mythical images. The 'I' as the experiencer is also in the
myth; it is not single and unique, but many, a flux of
vicissitudes, an archetypal illusion of self-identity; it is samsaric
and imaginal. The first metaphor of human existence is that
"we are not real." This means that we must "let go of all seem-
ingly irreducible objectifications of human personality" and
rediscover them as reflections of fantasy-image. For "only fan-
tasies are utterly, incontrovertibly real"; only they are "not redu-
cible to something other than their imagery"; "only they are as
they literally appear."[10]

In Hillman's opinion, Jung, in spite of his devastating attacks
on merely rational thinking and the imperial will or ego, was in-

clined to model his psychotherapy upon the hero's myth.[11] The ego (consciousness) and the unconscious are still portrayed by him as enemies to be brought together and reconciled in the course of the individuation process. In this way process is elevated into an axiomatic law of the psyche and is seen as the one and the only goal of psychic life. Hillman suspects that Jungians literalize process, forgetting that process is itself an archetypal idea and therefore just one of the perspectives by means of which psyche may be envisioned. To absolutize the individuation process is to re-introduce the obsolete monovision of reality under the guise of a superficially appealing "dynamism." It is also to distrust imagination and fantasy. Hillman believes that actually we feel shame not so much about the content of our fantasies, but because in fantasying "we give away our souls." The real shame is that "there is fantasy at all, because the revelation of the imaginal is the revelation of the uncontrollable, spontaneous, spirit, an immortal, divine part of the soul, the *memoria Dei* . . . The revelation of fantasies exposes the divine, which implies that *our fantasies are alien because they are not ours.* They arise from the transpersonal background."[12]

Hillman's psychology is soteriological and sacred in that it aims at the re-birth of the ego through imagination. In a shift of Copernican proportions we are enjoined to move from an ego-centered consciousness (the heroic ego) to an "imaginal ego" representing a more discontinuous, circular pattern, an "uroboric course, which is a circulation of the light and darkness." In this state the old and strong ego becomes "a tangent to the motion of the psyche as a whole," and it can participate in the larger circulation only "by abandoning itself, by forgetting, self-surrender, *metanoia,* etc."[13]

2. Unconscious Re-Visioned

There is a near-consensus among contemporary thinkers in philosophy and psychology that the Western Hebrew-Protestant consciousness which for so long has been governed

by an archetypal structure extolling the masculine or the Apollonian principle of light and order, suffers from *hubris:* the inflated ego is running riot. In psychology the neglect and fear of images has contributed to the obsession by one over-valued idea — the monotheistic Reformation man, the enemy of images, "tone deaf to all but the bugle, battling his way through binary choices, responsible, committed, progressing towards light . . . "[14] Western psychology has been looking at soul in the ego's mirror instead of seeing the ego in the mirror of the soul.

Glorification of the ego really started with the Cartesian blunder. Descartes's claim to rational clarity finally stabilized an ancient dualism, the split of subject from object, and resulted in the identification of 'mind' with conscious thinking. In a passage on this "treacherous dualism," L.L. Whyte says:

> Prior to Descartes and his sharp definition of the dualism there was no cause to contemplate the possible existence of unconscious mentality as part of a separate realm of mind. Many religious and speculative thinkers had taken for granted factors lying outside but influencing immediate awareness; Augustine's remarks on memory are a famous example. Until an attempt has been made (with apparent success) to choose *awareness* as the defining characteristic of an independent mode of being called mind, there was no occasion to invent the idea of *unconscious* mind as a provisional correction of that choice. It is only after Descartes that we find, first the idea and then the term, 'unconscious mind' entering European thought.[15]

It is common to refer this topographical model of the psyche to Freud, even though his later theory replaces the topographical unconscious with the *Id (das Es)* which he calls "a cauldron of seething excitement."[16] Jung, at least in his early theory, adopts most of Freud's assumptions about the nature of the psyche. He continually talks of the *contents* of consciousness and of the unconscious, imagining the psyche as some kind of container receiving sense impressions from the 'outer' world.[17]

Hillman strongly disapproves of the Jungian use of the "unconscious" for the paramount reason that it has come to obscure the imaginal. In Jungian orthodoxy the unconscious, which initially was a hypothesis, has been reified into a

hypostasis, a place filled with "real," "hard" and "tough" problems to be analysed and preferably "solved."[18]

In archetypal psychology "the unconscious" is mainly a tool for deepening, interiorizing and subjectifying the apparent contents and behavior of our psyche. "Recognition of the 'reality' of the 'unconscious' is a re-cognition of the depth, fullness, richness of psyche ... "[19] Psyche is not a *tabula rasa* (Locke); she is always imagining many things and her activity does not stop at the level of consciousness. We are always both conscious and unconscious; fantasies are part of all conscious life.

> We are dreaming all the time ... Part of the soul is continually remembering in mythopoetic speech, continually seeing, feeling, and hearing *sub specie aeternitatis* ... Our lives seem at one and the same moment to be uniquely our own and altogether new, yet to carry an ancestral aura, a quality of *déjà vu*.[20]

There is indeed an unconscious — some would say 'somnambulistic' — aspect to our everyday speech and behavior, but it is nothing more esoteric than "our unconsciousness of the collective fantasy that is dominating our viewpoints, ideas, behavior, by means of archetypes."[21] Quite prosaically the unconscious is un-awareness of the all-pervading presence of the imaginal in our so-called conscious life. But this unconsciousness is not really a separate compartment of the psyche and it has nothing intrinsically numinous about it. It is always, at least in principle, capable of becoming part of an enlarged vision — a state of clear, uninhibited awareness, of the full range and depth of the imaginal psyche.

The numinosity of the unconscious is due solely to its radically imaginal character which must remain invisible to our day-light consciousness. The psychic images are not identical to sense images or pictures but are rather *"images as metaphors."* In this capacity they *are* visible "but only to what is invisible in us. The invisible is perceived by means of the invisible."[22] In these words Hillman is expressing in archetypalist language a variation on the fundamental tenet of Hindu philosophy — *Tat twam asi;* for just as only imagination can imagine the soul, it is only *Atman* in me that knows *Brahman,* that 'I am *Brahman.*'

That "We Are Not Real"

Hillman's remarkable essay "The Dream and the Underworld"[23] represents another attempt to take the term "depth psychology" to its "logical and most serious consequences." Among other things, this implies that one must always go back to Heraclitus, the first thinker to root the world of phenomena not in air, or water, in atoms or numbers, but in soul.[24] The basic premise of this essay is that the dream world — the underworld of the unconscious — is a *cosmos* in its own right, distinct but not completely unrelated to the day-world. It is a cosmos rather than a chaos because it has its own laws and structures, even if these are "invisible" to our literal consciousness.

Essentially the 'underworld' is the realm of pure psyche or perhaps of the anima — the archetype of the psyche; it is a psychological cosmos whose "images are ontological statements about the soul, how it exists in and for itself beyond life."[25] The dream images lead a mirror-like existence reflecting the world of daily consciousness, but — and this is crucial — in the imaginal mode. "The shadow world in the depths . . . is this world in metaphor." So once again we find ourselves (do we ever?) in a world of topsy-turvydom: "from the psychic perspective of the underworld only shadow has substance . . . shadow is not only a moral or repressed or evil reflection to be integrated. Shadow is the very stuff of the soul."[26] If you will, *sub specie mortis* it is we, the 'real people,' who are the shadows of our souls. In the words of Heraclitus, "when we are alive our souls are dead and buried in us, but when we die, our souls come to life again and live." (fr. 26) Hillman interprets the Heraclitean fragment as follows:

> to 'sleep' places us in touch with the 'dead'; the *eidola*, essences, images; to be 'awake' is to be in touch with the sleeper, the ego-conscious personality. In the Romantic sense: during sleep we are awake and alive; in life asleep.[27]

Hillman distinguishes between the ego of daily life (the controlling ego) and the ego of our dreams, the imaginal ego; between the two, connections are rather precarious. Dreams only rarely reflect circumstances and events of one's personal life; most of

the time they are distressingly indifferent to what may appear cataclysmic to our quotidian ego. "Usually what we do in dreams shocks the waking ego. But perhaps what we do during the day is equally disturbing to the I of our dreams." In contrast to the Jungian view that dreams are compensatory to the left-overs (Freud's *Tagesreste*) of our conscious experiences (using the dreams to strengthen the old ego) Hillman prefers to think that

> perhaps dreams . . . prepare the imaginal ego for old age, death, and fate by soaking it through and through in *memoria*. Perhaps the point of dreams has very little to do with our daily concerns, and their purpose is the soul-making of the imaginal ego.[28]

The dream is not so much a comment upon our so-called waking consciousness as it is a digestive process converting bits and pieces of the day into psychic substance, a transformation of the dayworld from a linear and rational reality into a metaphorical and uroboric reality. The aim of the Freudian 'dreamwork,' according to Hillman, is a radical alteration of our ordinary modes of consciousness: a transition from the heroic stance to the poetic. Thus we work on dreams not to substantiate the ego, but *"to make psychic reality, to make soul by coagulating the imagination."*[29]

If, as Jung said, modern man is in search of a lost soul, this soul, adds Hillman, "is lost partly in life"; it is lost through the attempts of modern psychotherapy to 'explain' dreams by using the guidelines of the heroic ego. The inevitable result of this rationalistic bias is that the ego becomes strong at the cost of soul and the imaginal.[30]

The Western concept of the unconscious, as re-visioned by Hillman, has striking parallels in Zen Buddhist experience.[31] Zen (*ch'an* in Chinese) is a product of the combination of Mahayana Buddhism with Chinese Taoism which was later transported to Japan and further refined there. The introduction of Zen into China is attributed to the semilegendary Indian monk Bodhidharma (sixth century A.D.) who is also credited with the composition of a four-line verse purporting to contain a summary of Zen doctrine. The verse reads:

That "We Are Not Real"

A special tradition outside the scriptures,
No dependence upon words and letters,
Direct pointing at the soul of man,
Seeing into one's own nature and the attainment of buddhahood.

The key phrase of this verse is "Direct pointing at the soul of man." In other texts of Bodhidharma's verse, the word here given as soul is "mind" (*h'sin*). Yet mind in this sense is clearly not the seat of our empirical consciousness; it is rather the ground of the soul or of our being. In the Zen context "mind has a kind of ontological value since it is not *my* awareness but rather the world's awareness of itself in me. The gist is that my 'identity' is to be sought not in separation from the world but in union with all that is. According to Zen the fundamental cause of suffering (*dukkha*) lies in the delusion that man can isolate himself from the rest of life. Like the original Buddhism (Theravada) and its later development in Mahayana, Zen holds that all separate entities are without permanence (*anatta* and *anicca*), but it completes this denial of substance by affirming total interrelatedness of all things. Reality is "suchness" (*tathata*) which has a close affinity with the Chinese Tao or the "Way of things." Things are "just so," but of course only from the perspective of the 'soul' or 'mind,' not in their literal actuality.

The secret of Zen lies in its categorical refusal to try to capture and to stabilize the flow of things in the net of our intellectual definitions. Reality is like Maeterlinck's blue birds which lose their color in the cage. To definitions which kill, Zen prefers immediate awareness of the intermediate realm of the psyche in which things live and move in their suchness, i.e., *as images*. What in Zen is called *satori* (illumination, enlightenment) is a change, a *metanoia* from the heroic basis of consciousness to the poetic basis of consciousness. *Satori* is essentially a state of clear awareness and spontaneity, invisible and unreal to the quotidian mind (literalistic and rational consciousness) because of its estrangement from the underworld.

D.T. Suzuki, writing about the art of swordsmanship in ancient Japan, translates the Japanese *mushin* ('no-mind') as "the Unconscious." Then he says

> Psychologically speaking, [the swordman] gives [himself] up unreservedly to an unknown 'power' that comes from nowhere and yet seems strong enough to possess the whole field of consciousness and make it work for the unknown ... But [this state] ought not to be confused with the helpless passivity of an inorganic thing ... He [i.e., swordsman] is 'unconsciously conscious' or 'consciously unconscious.' "[32]

The *mushin,* in a phrase of Alan Watts, is "highly aware *unself*-consciousness."[33]

In another passage which reminds us of Hillman's refusal to identify the soul with any particular viewpoint, Shen-hui (670-762), the Chinese Zen master, defines the unconscious as follows:

> Be not attached to form. Not to be attached to form means Suchness. What is meant by Suchness? It means the Unconscious. What is the Unconscious? It is not to think of being and non-being; it is not to think of good and bad; it is not to think of having limits; it is not to think of measurements (or of non-measurements), it is not to think of enlightenment, nor is it to think of being enlightened; it is not to think of Nirvana, nor is it to think of attaining Nirvana: this is the Unconscious.[34]

In terms of archetypal psychology, psychic existence is "unconscious" existence when it is detached from the "contents" of the psyche; it is equivalent to a realization that these contents, taken together, i.e., in their mutual complicatedness and polyvalence, *are* the (imaginal) psyche. To use the Zen term, soul is "suchness" when, having shed all literalisms, it becomes aware of its limitless depth and multicentricity. But again, such awareness is not had by the soul: it *is* the soul.

3. Unconscious in Transpersonal Psychology

Hillman's aversion to the Jungian unconscious is shared by a whole group of writers engaged in developing a "transpersonal psychology" along the lines of Zen and Tibetan Buddhism. Whenever the name of Jung is mentioned in these circles, it is pointed out that his model of the unconscious as a separate system containing innate unconscious ideations is inadequate for understanding meditation. The Jungian model of

perceived as dualistic in that it reifies aspects of experience into unconscious contents (instinct, archetypes) and thereby continues the Cartesian view of mind as a place or a realm 'inside' the organism, inherently distinct and separate from the total world process.

> The unconscious has become a catch-all term that appears to explain phenomena for which there is no other explanation, without explaining very much at all, since its meaning remains obscure.[35]

There is no denying that Jung himself saw meditation as a one-sided attempt to withdraw from the world, dissolving the ego and leading back to an indefinite experience of oneness and timelessness. To him it was a kind of surrender to the Collective Unconscious — a dangerous indulgence that too lightly dismisses the importance of the ego: "An ego-less mental condition can only be unconscious to us for the simple reason that there would be nobody to witness it." Jung could not imagine "a conscious mental state that does not relate to an ego."[36]

In effect Jungians often talk as though the unconscious is a container ("container-fantasy") with a distinct set of contents (almost with a mind of its own) which are like those of consciousness, except that they remain below the threshold of awareness. Meditation then is seen as an inward journey, as an introverted probing of the "hidden treasures" of the unconscious, eventually leading to ever new forms of narcissistic self-absorption.

Writers on Zen uniformly repudiate the Jungian model of the unconscious for the ostensible reason that the aim of Zen practice is not so much to integrate the unconscious into consciousness as to break up the dualistic structure of consciousness-and-unconsciousness. For example, John Wellwood, in an effort to re-define unconscious processes, calls for a:

> holistic mode of organizing experience, a mode of relationship which transcends the normal workings of focal attention by grasping multiple connections as a whole, without serial differentiation.[37]

The unconscious process as "a mode of relationship" is in fact unknown and unknowable only to the focal and selective type

of consciousness, but it is fully known or rather intuited (I should prefer to say "imagined") as the transpersonal background of an experiential field whose foreground consists of discrete, sharply differentiated figures. In states of wider awareness which are characterized by diffuse attention, we can apprehend not only the foreground (discrete figures) but also and at the same time its "unconscious" ground; we find ourselves in direct touch with the whole experiential field, or as Buddhists say, with "things as they are."[38]

Notwithstanding Jung, enlightenment, according to Eastern texts, is a clear and precise way of being and living in the world. Chogyam Trungpa, for example, defines the meditative state in terms of clear awareness, requiring no inward concentration. In meditation, he says,

> there is no concentrating . . . at all. In fact, without the external world, the world of phenomena, meditation would be almost impossible to practice, for the individual and the external world are not separate, but merely coexist together.[39]

According to H. Guenther, "the point of meditation is not to develop trance-like states; rather it is to sharpen perceptions, to see things as they are."[40] As I tried to make it clear earlier, the detachment or non-attachment which accompanies meditative states, should not be confused with lack of involvement in the viscid realities of life. Meditative stand-offishness is nothing more than a refusal to take seriously the obfuscations of our habitually literalistic mind. On the positive side, meditation is an attempt to experience the interpenetrative (metaphorical) quality of all things because professedly that is precisely and 'realistically' how they are. Meditation is soul-making.

The new approach to unconscious or *unself*-conscious functioning is based on the notion that human beings are related to the world in a diffuse way prior to any conscious articulation of this primordial relatedness. It is also conceivable that what used to be called our feelings of "absolute dependence," infinity and numinosity in the presence of a "wholly Other" (Schleiermacher, Otto), is merely a quasi-theological way of saying that our focal, linear mind is embedded in a much vaster organismic

process. Being unable to pinpoint, to "stop" this cosmic transaction, we are only too prone to deny its reality or to treat it as separate and even alien to ourselves. Thus we avoid and fear what is most "unconscious" in us — our pre-personal, non-human relatedness to all things. We avoid and fear it though for a perfectly good, because culturally sanctioned, reason: fullness of life on the trans-individual or imaginal level implies sacrifice of the ego, acceptance of little deaths from moment to moment, since there is nothing on that level to hold on to or to identify oneself with. As Hillman was led to observe, what we distrust in fantasying and imagining is the revelation of the uncontrollable, spontaneous spirit. Ernest Becker points to the same when he says that we maintain our normality ("normal neurosis") by refusing and repressing our complete openness and vulnerability to the world. We live in fear of both life and death and so we develop defenses allowing us to feel that we control our life and death, that we have a unique and self-fashioned identity to which we don't dare to say "get lost."[41]

It is of considerable importance to realize that the experience of the transpersonal ground, rare as it may be, is neither particularly mystical or esoteric nor introverted, but a clear awareness of the immediacy of being, of that "paradise of immediacy" which, according to Cassirer, is forever closed to the "symbolic animal." Enlightenment does not issue in precarious acquaintance with the "regions of inner space" or in the acquisition of a new perspective toward the world. It is rather the case — somewhat as in Hillman's psychology — that all perspectives and viewpoints, having been seen for what they are, i.e., momentary constellations of archetypal images, are no longer confused with psychic reality or the Jungian *esse in anima*. One could also say in good conscience that enlightenment is an experiential realization of Hillman's "radical or imaginal relativism" — a reduction to the imaginal. In this state images no longer hide a different or deeper reality, but are experienced and accepted in their own being, as "utterly, incontrovertibly real." In J. Wellwood's words,

awakening is not additive in the sense of unconscious contents

breaking through into consciousness, but if anything, substractive, in
that it removes fixations with any particular content.[42]

The removal of fixations is no doubt congruent with the Hindu
neti, neti as applied to *Brahman*, for, as I pointed out, *Tat
twam asi.* supplemented by *neti, neti* also leads to the reali-
zation that *Brahman* is "now this," "now that," a mirror-play of
mutually interpenetrating events, persons and things. None of
these events, persons and things are essences or substances in
the essentialist Aristotelian tradition (answering the question
"what?"); they are rather roles or masks assumed by *Brahman*,
the Great Actor who pretends that he is you and I, now this,
now that (answering the question "who?"). But when we say
"pretrends" we should not mean that *Brahman* deliberately
deceives; on the contrary, he is as much in the play as the artist
is in his work of art, for *Maya-Shakti*, his consort and the queen,
is nothing less than the poetic basis of his consciousness. She is
the eternal Eve who ate the apple and was herself the apple,
the *natura naturans*, the pre-eminent enigma.[43]
Brahman-Maya-Shakti, from the viewpoint of archetypal
psychology, is Pure Poetry (rather than Pure Bliss).

In Tantric Buddhism the experience of *nirvana* is symbolized
by the *mandala* — the "centerless center." "The mandala prin-
ciple expresses the experience of seeing the relatedness of all
phenomena ... The patterns of phenomena become clear
because there is no partiality in one's perspective. All corners
are visible, awareness is all-pervading."[44] It is instructive that the
subtlety of *mandala* symbolism was not adequately understood
by Jung, who interpreted it as the "premonition of a center of
personality, a kind of central point within the psyche to which
everything is related."[45] In common with the mainstream of
Western psychology, Jung insisted upon consciousness depen-
dent upon a center (ego), and he preferred to see the mandala
as pointing from this ego to a larger self (the wholeness of man),
as the "true" center of personality.

To Jung an egoless state of consciousness is equivalent to
the collective unconscious — a separate system of archetypes
which, in spite of their psychoïd nature, are "mainly" inside the

organism. In Buddhism and in transpersonal psychology, on the other hand, the unconscious refers to

> the living, dynamic, holistic process that shapes and structures the *outer* reality . . . In this sense everything in nature has an inner reality (its holistic, expressive side) which is not separate from the inner reality of the human process.[46]

Our extended notion of the unconscious may be translated into the language of archetypal psychology by saying that the word "unconscious" connotes inwardness and depth of a psyche which, far from being the property of an individual, is "interiorly within all things."[47] In Jung's own terms, the psyche is perceived among the primitives as the source of life, a ghostlike presence which has objective reality: "The psyche is not, as it is to us, the epitome of all that is subjective and subject to the will; on the contrary, it is something objective, self-subsistent, and living its own life."[48]

It is the same with us, the moderns. As Jung sees it, our sense of 'I,' ego-consciousness, grows out of unconscious life. "Life and psyche existed . . . before I could say 'I,' and when this 'I' disappears, as in sleep or unconsciousness, life and psyche still go on . . . "[49] Cassirer and Barfield indicated as much by submitting that our sense of "me-ness" and egoity first emerged from the mythical state of pure imagination. We who imagine that we fabricate or own our souls are really their simulacra, said Hillman. In any event, as Bruno Snell with much perspicuity has suggested, man could never have come to experience a rock anthropomorphically if he had not also experienced himself "petromorphically."[50]

V

From Myth To Illumination

1. The Common Root of Myth and Language

Denigration of imagination and denial of the power of images in Western tradition has been accompanied by a progressive emptying of what sometimes are called "big words" (Truth, Justice, Harmony). Certain words have moved from being carriers of archetypal significance and power to the status of mere names and labels with only subjective reality. Beginning with nominalism in the fourteenth century and culminating in Wittgenstein and Sartre, we have witnessed an eclipse of the magic function of the word and its replacement by the semantic function. For example, according to the canons of logical symbolism (Russell, Carnap, Wittgenstein) only thoughts which can be arranged like pieces of clothing side by side on the clothesline can be spoken at all. Any idea which does not lend itself to this procedure is said to be ineffable, incommunicable by means of words and thus "meaningless." At best it can be taken as an expression of emotions, feelings, desires, as a symptom of 'inner life,' like tears and laughter, crooning, or profanity. Examples of such utterances are cries like "Oh, Oh," or on a higher level, lyric verse. In this view human thought is but a "tiny, grammar-bound island in the midst of a sea of feeling expressed by ... sheer babble." Only what can be "projected" in discursive form is accessible to human mind at all.[1]

As an antidote to this flattening of language, Hillman has issued a call for "a new angelology of words." We must

reinstate, he says, the angel aspect (the message-bearer) of the word, because "words, like angels, are powers which have invisible power over us. They are personal presences . . . "[2]

The purpose of this part of my essay, however, is merely to get some idea of the power and substance which has inhered in the words of language when human consciousness and the processes of nature were one single process. For this we must go back once again to that crepuscular intermediate stage of mythical imagination which Barfield and Cassirer have identified as the origin of language. By the same means I hope to provide additional evidence for my proposition that imagining is "potentially" (Barfield) the Western mode of release from the delusion of egohood.

Cassirer has already convincingly shown that in the early stages of myth the inner and the outer worlds do not exist as two separate, sharply distinguishable entities. Primitive thought is never purely subjective; it cleaves to material phenomena as part of its content. What we observe in the past is an external, material language referring to the outer world of nature. Gradually however this primitive material language more and more becomes an inner or immaterial language.

To the student of history, language today appears at first sight to consist of what has been called "a tissue of faded metaphors." Every expression we employ, apart from those that are connected with the most rudimentary objects and actions, is a metaphor. For example, "expression" means "what is squeezed out," "employ" is to "twine in," to "connect" is "weave together," "rudimentary" means "in the rough state," etc. The classical example is the word "spirit" which primarily means "wind."

As Barfield explains,

> we find that all words used to describe the 'inside' of ourselves, whether it be a thought or feeling, can be clearly seen to have come down to us from an earlier period when they also had reference to the outside world. The further back you go in time, the more metaphorical you find language becoming.[3]

Ultimately it must be admitted that the words of our language are emblematic of nature, of man's intrinsic relatedness to the

non-human. According to Barfield, it was "out of man's rich awareness of this meaningful relation between himself and nature that language originally came to birth."[4]

Language, like myth, originates in imagination, which Susanne Langer called "the primary talent of the human mind."[5] In this sense language is an *Urphänomen* — an original and irreducible fact not to be explained causally or genetically through some order of psycho-biological phenomena. Like mythical images, language is essentially hypostatic in that it seeks to distinguish, emphasize and hold the object of feeling rather than to communicate the feeling itself.[6] Man has never been content to be a merely passive recipient of an experience: he wants to conceive it, preserve it in order to think about it. Cassirer maintains that already in myth there is a tendency "not simply to glide along in the stream of feeling and affective agitation, but to fetter this movement and to bring it into a kind of spiritual focus, into the unity of an image."[7]

However, our primal man (like the poet and mythmaker in everyone) is not eager to confront the world in an attitude of contemplation from the distance created by the image or symbol, but is captivated by and immersed in the immediately given: "all other things are lost to the mind thus enthralled ... Only the present reality fills the entire subjective realm." There is nothing beside or beyond the particular content of experience to which it could be compared; "its mere presence is the sum of all Being."[8]

It is for this reason that *naming* must be regarded as the very essence of the mythical process of imagination. Names in the archaic societies are not mere conventional signs (or symbols in the broad sense) but are treated as physical proxies for their bearers. A person's ego, his very self and personality is indissolubly linked with his name. For example, among the Algonquins, a man who bears the same name as some other person is looked upon as the latter's *alter ego*. The human personality is not perceived as something fixed and unchanging; every stage of a man's life embodies a new self. A boy at puberty receives a new name because, by virtue of his initiation, he

has been reborn as a man, probably the reincarnation of one of his ancestors. Names, says Susanne Langer, "are the very essence of mythical symbols. Nothing on earth is a more concentrated point of sheer meaning than the little, transient, invisible breath that constitutes the spoken word."[9] In the words of Cassirer, "whatever has been fixed by a name, henceforth is not only real, but is Reality."[10]

In all mythical cosmogonies the word functions as an independent and primary force. For example, in India we find the power of the spoken word (*Vac*) exalted even above the might of the gods themselves.[11] In ancient Egyptian theology, the creator-god *Ptah* produces and governs all gods and men, all animals through the thought of his heart and the command of his tongue. This hypostatization of the word is, in Cassirer's view, crucially important in the development of human mentality: "the word has to be conceived in the mythical mode, as substantial being and power, before it can be comprehended as an ideal instrument, an organon of the mind . . . "[12]

To the extent therefore that the hypostatized word and the mythical image are indistinguishable, language and myth, according to Cassirer, have a common root and are the products of an ultimately identical mental function. Myth arises from an emotional tension between man and his environment:

> When external reality . . . overcomes man in sheer immediacy, with emotions of fear and hope, terror or wish fulfillment: then the spark jumps somehow across, the tension finds release, and confronts the mind as a god or as a daemon . . . [But] as soon as the spark has jumped across, as soon as the tension and emotion of the moment has found its discharge in the word of the mythical image, a sort of turning point has occurred in human mentality: the inner excitement which was a mere subjective state has vanished, and has been resolved into the objective form of myth or of speech.[13]

It is impossible to ascertain the age of language and myth since their origins lie in pre-history. Nevertheless it would seem very plausible, if we follow Cassirer, that they are twin creatures, springing from the same tendency to see reality imagistically or symbolically. Both language and myth are part of the same basic mental activity,

> a concentration and heightening of simple sensory experience . . .
> they are both resolutions of an inner tension, the representation of
> subjective impulses and excitations . . . in the vocables of speech and
> in primitive mythic figurations . . . [14]

Man, whether he is a cannibal who has lived for centuries in the
most remote areas of the globe, or the modern *animal
symbolicum,* is affected by every impression that he receives,
by every hope that lures him and by every danger that
threatens him. Usener, whose studies in the history of language
and religion Cassirer uses as a basis for his theoretical construc-
tions, has called the objectifications of such intense and fleeting
impressions "the momentary gods."

> Whatever comes to us suddenly like a sending from heaven,
> whatever rejoices or grieves or oppresses us, seems to the religious
> consciousness like a divine being . . . daimon. [15]

From the vantage point of archetypal psychology, these
demons are the imaginal essences of words, endowed with
numinous power. What Hillman calls "the angel aspect of the
word" is the "inherence of soul in words."[16] Without soul
speech would not move us; it would become a *flatus voci,* a
waste of breath, or at best an operational tool. Moreover, if
soul, as we have repeatedly emphasized, is a wider notion than
man, connecting him with the non-human mythical realm of
natura naturans (the *chthon* aspect of nature), then we must
also proffer that through the word the world speaks. The word
is not exclusively human.

Language in its origin is what Jung called "fantasy thinking"
or simply imaginal, corresponding to the imaginal core of reali-
ty which it expresses; it is the speech of Adam before the fall
naming things into being. In this sense language is primarily
and essentially not a means of communication at all, but poetry
or, more precisely, it springs from the poetic basis of our mind.
Language does not belong to us; it's rather the case that we
belong to the angels and gods who address us through
language.

From Myth to Illumination

2. Myth, Symbol and Religion

Mythical images tend to become symbols (gods become diseases ...) only when the objects of the outer world, instead of acting directly on the emotions of our early man, begin to recede into a distance, when they can be looked at and recognized again whenever they appear. The transformation of images into symbols more or less coincides with our gradual separation from embeddedness in the processes of nature.[17] Whereas the primitive lives in the momentary, and spends himself in the momentary, the symboling animal must step twice, in fact, many times into the same Heraclitean flux.

The symbol is born when the image acquires the function of representation, or, in Cassirer's words,

> when we succeed ... in compressing a total phenomenon into one of its factors, in concentrating it symbolically ... only then do we raise it out of the stream of temporary change ... only then does it become possible to find again in the simple, as it were, punctual 'here' and 'now' of present experience a 'not-here' and a 'not-now.'[18]

At this juncture a differentiation is achieved between the image and its content: the image begins to function as the "representative of a totality," as the first "universal," i.e., as a symbol.[19] Symbols, unlike mythical images which serve as proxies for things and events in physical world, are part of the human world of meaning and rationality — the *globus intellectualis* of the symbolic animal.

Historically (not archetypally) speaking the transition from image to symbol is a relatively late achievement.[20] Man must pass through a long "development" before he acquires the specific consciousness of the symbol. Cassirer equates this transition with the progression from the magical-mythical worldview to a religious one. With the advent of religious consciousness the mythical images acquire a new meaning: they no longer signify themselves, but have become symbolic or metaphoric expressions of a spiritual reality.[21] As Wilbur Urban explains, religion "makes use of sensuous pictures and signs, but at the same time it knows them to be such. It draws the distinction between mere existence and meaning."[22]

Every religion, according to Cassirer, comes to a point when it must break loose from its mythical foundation and begin to recognize sensuous images as inadequate to the meaning which they reveal. In this process images become pointers to a spiritual reality which they represent but never fully exhaust. Within the religious point of view things and events do not signify themselves, but have become an indication of something 'other,' something 'transcendent.' The dialectic of religious consciousness consists in "the striving beyond the mythical image world and an indissoluble attachment to this same world."[23] It is a process of progressive *spiritualization* and apollonization ineluctably carrying religion to a point where "the question of its truth and meaning shifts into the question of the reality of its object . . . "[24]

It would seem that from the standpoint of archetypal psychology, the religious process of spiritualization can be imaged as a kind of Second Fall — as the abandonment (forgetfulness) of the middle position which is also the place of the soul; an inexorable moving away from the world of imagination which, as we have by now established, is neither exclusively physical and material nor purely spiritual and abstract. I may add that one could also detect in this process — without using magnifying lenses — an uncanny alliance between religion and scientific-technological ideology. Religion no longer deals with man's fall, but participates in it with its own private *hosannas* and *in excelsis.*

It bears repeating at this juncture that the fundamental principle of the psyche is differentiation and multivalency. There can be no ideal norm for man, for the imaginal psyche

> decomposes . . . our *spiritual* vision of perfectibility of man, cracks all normative images, presenting instead a psychological fantasy of man to which neither naturalism nor spiritualism can apply.

In order to make plain the essential freedom of the soul, Hillman invokes the Buddha himself.

> The falling apart of the individual at death, the dissolution of his complexity, which the Buddha taught in his last cautionary enigma — 'Decay is inherent in all composite things. Work on your salvation

with diligence' — points to the absolute non-normality of each individual person.[25]

Accordingly, the kind of religion which Hillman's "radical relativism" requires must be congruent with actual psychic reality: a religion which is derived not merely from spirit with its monistic bias, but rather from the soul's inherent multiplicity. And that is psychological polytheism.

"A polytheistic vision implies that all days refer to Gods ... that the Gods are in daily life." This means that polytheistic thinking abolishes the boundary between a transcendent God and a secular world, between the divine and the human, the subjective and the objective, the inner and the outer. They are all seen as outworn bifurcations. The only valid distinctions (and there must be distinctions because the psyche itself constantly makes them) are among the Gods as "modes of psychological existence operating always and everywhere." In Hillman's scheme of things, a return to polytheism is not an invitation to worship many Gods and Goddesses 'out-there' or 'in-here.' Polytheism must lead to a re-cognition, a remembrance (*anamnesis* in the Platonic sense) that Gods and Goddesses live through our psychic structures; that they are present in the fundamental nature of our being and behavior — even as dis-eases, as a thorn in the soul's flesh. According to David Miller, Hillman's psychology paradoxically avoids psychologization, for he "is not saying that Gods and Goddesses are aspects of *my* psychological history, subjective dimensions of mankind projected outward onto mythical names and stories." Hillman is above all concerned with the impersonal dimension of the psyche; by reaching below or beyond the merely personal he "discovers that Gods and Goddesses are worlds of being and meaning in which my personal life participates."

Psychologically expressed, the gods of polytheism are none other than the archetypal, "unconscious" structures of the *psyche* which (and who), by definition, reflects the world and is capable of clear and precise vision (as in Zen) provided she is not clogged by the divisive, isolating and compulsively unifying

tendencies of the spirit. In David Miller's words, the transpersonal nature of the archetypes gives us "an Archimedean point of leverage on what would otherwise be isolated, anecdotal, biographical meaning."[26]

Hillman's polytheistic psychology also claims to be "non-agnostic." It is here that the cardinal difference between religion and psychology is made clear: while in religion gods are believed as literal entities or theological substances, in archetypal psychology they are imagined. Religion approaches gods with ritual, prayer, sacrifice, creed and other paraphernalia; psychology approaches them through imagining and personifying. Gods are formulated ambiguously, as metaphors for various modes of experience and as numinous borderline persons. They are cosmic perspectives in which the soul participates — always, necessarily, as if by consanguinity.[27]

Thus polytheistic psychology is non-agnostic even as it refrains from theological assertions and is not concerned with faith or with the "death of God." From a strictly imaginal point of view gods never die; they can be either ignored at the peril of our own souls or recollected and invoked in our behavior. Gods are the *a priori*, the *archai*, the prime movers within all experiences and all attitudes. A polytheistic religion (mythology) must be therefore the first principle of any psychology concerned with the well-being of soul. Contrary to William James who in his *Varieties of Religious Experience* treated religion as a phenomenon of soul, Hillman would "examine psychological observations through religious positions" always asking the question "which God is at work." Psychology now becomes — *terribile dictu* — a "variety of religious experience." In other words, Hillman opts for a "religion of psychology" or a sacred psychology instead of a psychology of religion, for today, he maintains, it is "not a question of religion turning to psychology — no, psychology is simply going home." It is going where the soul is.

I cannot help contemplating this reversal as a masterstroke that consummates Jung's dissolution of the noumena-phenomena distinction and at the same time liberates man

from the imprisonment in Cassirer's symbolic universe. For if religion, as Hillman understands it, is inseparable from the soul-making process and if soul-making occurs not only in man but in the whole of being, then and only then is the universe of symbols transformed into a fully transparent, theophanic and imaginal universe. The human soul, instead of being a mere window into the world, becomes a mirror-play simultaneously reflecting and re-projecting the same light from which it originally came forth. One might suggest that the man who, according to Barfield, was made by the archetypal substance of myth, returns to his maker.

Last but not least, Hillman's approach offers an alternative to both dualism and monism. Dualism, like all other "isms," is, according to Hillman, a fantasy of the psyche, an imaginal configuration which depends on monism (or momism), since all dualities are "either faces of the same, or assume a unity as their precondition or ultimate goal (identity of opposites)." Even a radically irreconcilable dualism (as, for example, in Zoroastrianism) is the "struggle between parallel Ones."[28] Monism, on the other hand, which strives for unity within diversity, is "an inflating exercise" leading to the identification of ego with the One or to what Jung called "monotheism of consciousness." In Hillman's psychology the word "unity" refers not to a center of personality which even Jung recognized as an unattainable ideal,[29] but to the admission that "existence is a psychic network. . . . " The so-called unity of soul is merely "unity of an outlook that sees all events as psychic realities."[30]

3. Hillman, Heraclitus and the Buddha
or
Vice Versa

Hillman's view of religion, on the face of it, may appear to be the very opposite of the general Buddhist attitude toward religion. The Buddha emphatically rejects along with the idea of a substantial soul, not only its celestial counterpart, the idea of substantial Godhead, but also the gods of popular pantheon,

since they too, like everything individual, are impermanent and perishable. Gods are discarded because they partake of the nature of the world of names and forms. At the same time, however, Buddhism reinstates the mythical figures of Gods and Goddesses as convenient means to carry the adept to the other shore, moving and awakening the mind and calling it beyond these imaginary shapes.

It is the same in Hillman's sacred psychology: gods are viewed as necessary guiding fictions in service of the soul; they are there not to be *believed* but to be *imagined* as the psychopomps and guides in the never-ending adventure of soul-making. Polytheistic psychology gives its due to each and every god and demon; it

> would not suspend the commandment to have 'no other Gods
> before me,' but would extend that commandment for each mode of
> consciousness . . . Each archetypal possibility of the psyche . . . could
> follow its principle of individuation within its particular divine
> model.[31]

The Buddhist stance toward Gods is not different from the way in which images and fantasies are treated in Eastern disciplines of meditation. Images — of whatever provenance — are simply watched in their pure "just-so-isness" without trying rationally to identify and explain them. For the meditator, just like the depth psychologist, knows that the imaginal resists being known except in its own terms. In Mary Watkins' words, "image requires image. Image evokes image . . . we can say what the imaginal *is like,* but cannot utter what it *is.*"[32]

From the viewpoint of Cassirer's philosophy of symbolic forms, Buddhism is an atheistic religion. This is not so much because Buddhism denies the existence of the Gods, but their existence is irrelevant and meaningless in the light of a more central affirmation. In Cassirer's opinion, the central thesis of Buddhism, its basic act of religious synthesis, is that "only the process itself is ultimately apprehended . . . while every supposed substratum of this process dissolves and finally sinks into nothingness."[33] What stamps a religion as doctrine, is not the content, but solely its form, that is, its affirmation of a specific 'order' and meaning.

The form of Buddhism consists in the insight that the whole of reality is process (not *in* process) and that our view of things as discrete, solid entities is due to our lack of detachment from what we perceive, think or feel. From a radically processional stance, the *manifest* content of things (their perpetual state of flux) is imbued with its own meaning, and the appearance (the form) of things is indistinguishable from their (archetypal) background. *Nirvana* is the same as the world; it is not only 'in' and 'with' you, but you are nothing but it. T.R. Murti has lucidly summed up the Madhyamika (Middle Path) position on this question.

> There is no difference whatever between Nirvana and samsara; Noumenon and Phenomenon are not two separate sets of entities, nor are they two states of the same thing . . . The absolute looked at through the thought-forms of constructive imagination [Kant's productive imagination] is the empirical world; and conversely, the absolute is the world viewed *sub specie aeternitatis* without the distorting media of thought.[34]

It would be, however, almost impossible for Cassirer's symbolic animal to acquiesce in the Buddhist equation of *nirvana* and *samsara*. Although Cassirer, in a further advance on Kant's Copernican revolution, has rendered the dichotomy between the noumenal and the phenomenal irrelevant, he seems to have established a new opposition between man and his own creations:

> In creating its mythical, artistic forms the spirit does not recognize itself in them as a creative principle. Each of these spheres becomes for it an independent 'outward' world . . . the I creates for itself a kind of opposite in its own products which seem to it wholly objective. And it can contemplate itself only in this kind of projection.[35]

Thus the *animal symbolicum* seems to be doubly alienated: first, through his imprisonment in the cultural universe of symbolic forms; second, from his own creations. As a sympathetic interpreter of Cassirer puts it, again and again man has tried to lift the veil which separates him from his own creation, but the fear was greater, the fear that "curiosity could only yield the horror: the look into the abyss of nothing — or the abyss of his own self."[36] But then Kant too recoiled from the abyss of the

transcendental imagination. There is little doubt, however, that an attentive look into the psyche, instead of yielding horror would reveal the archetypal "unconscious" ground of every — including Cassirer's — focally determined vision. It all depends how one looks. Horror, or alternatively somnambulism, ensues only if we become glued to what we see.

Rather than turning to Jungian psychology or, for that matter to Buddhist sources, Cassirer, in his search for the "paradise of immediacy," returns to pre-Socratic Greece. Greek thought, according to Cassirer, in contrast to the mythical nostalgia for the beginnings and the prophetic (Old Testament) orientation toward the future, is characterized by a twofold attitude:

> the attachment to temporal intuition and striving to surpass it by the thought of a unity of law, indwelling and immediately grasped in it.

Particularly it is Heraclitus who resembles the Buddha in that he too focuses on the flux of things. Unlike the Buddha, however, he is not led to the rejection of existence. Cassirer perceives the contrast between the two as follows. While in the Buddhist legend Siddhartha, the king's son, flees from his first encounter with old age, sickness, and death to become an ascetic and penitent, "Heraclitus *seeks* all this and dwells on it, because he needs it as a means of grasping the secret of the logos which *is* only by virtue of the fact that it is perpetually splitting into opposites."

Without attempting an exegesis of Cassirer's treatment of Buddhism, it should be pointed out that his interpretation of the Heraclitean thought, so far from diverging from Buddhism, may be regarded as an analogue of the later Mahayana understanding of the Middle Path.[37] For what Cassirer takes to be Heraclitus' more adequate grasp of impermanence and change over against the Buddhist flight from transience and suffering is precisely what we find in the fully developed Buddhist view of reality. But let us relish for the moment Cassirer's encomium of Heraclitus — the "unknown" Buddha of the gentiles.

In Cassirer's view Heraclitus' significance lies in his new valuation and "redemption" of time. He is captivated not by

the naked fact of change but by its meaning — the Logos or the idea of measure immanent in all events. It is the intuition of a hidden harmony within the flowing and passing of things that relieves us of the burden of change.

> Now the temporal no longer appears as a deficiency pure and simple, as limitation and suffering; in it, rather is disclosed the innermost life of the divine. There is no peace and beatitude in the negation of change, in perfection without tension; rather, 'disease makes health pleasant and good, hunger satisfaction, weariness rest' (fr. 111).[38]

In the Heraclitean cosmos one lives in the now, yet without being confined within it: the 'I' seems to hover free in the moment, untouched by its pain. But this is possible only because in Heraclitus' speculative view of time, man has achieved a sort of objectivization of his own psyche: he can look at his emotions and desires from a distance as an artist looks at his own creations. It is art that teaches man what Leonardo da Vinci called *saper vedere* — how to see: experience of art transports us into a state of "sympathetic vision" of things. We acquire a new attitude toward our emotions; instead of being at their mercy, we can look through them and are brought to a state of peace and rest. "Our passions are no longer dark and impenetrable; they become, as it were, transparent." In artistic experience, "the highest intensification of our emotional life" gives us at the same time "a sense of repose."[39]

According to Cassirer, the Heraclitean concept of time "reveals a tendency which would seem to relate it closely to the artistic view." For he who "no longer clings to the content of events but apprehends their form — for him this content is ultimately raised to the level of form, the substance of being and becoming is transformed into pure play." It is in this light, perhaps, adds Cassirer, that we should understand the strangely profound saying of Heraclitus: "Time is a child playing a game of draughts; the kingship is in the hands of the child." (fr. 52)[40]

What Cassirer calls the "form" of events is, from the standpoint of archetypal psychology, the poetry of events, their metaphoric and imaginal essence. Events as poetry do not affect us in the same way as they do in their actuality and

literalness. Imagination establishes distance — a distance between myself and my actions and emotions so that I can see them as less personal and more like performances in a drama in which I am not totally involved; I can see through the mask of my personality. But what I thus see beyond the mask is no more than the play itself, *lila, maya,* time, "the child playing a game of draughts." The child is the king.[41]

The close affinity between the speculations of Heraclitus and Buddhism is best seen by comparing the former with the central teaching of the *Avatamsaka Sutra,* the chief text of the Japanese Kegon school which, in the opinion of D.T. Suzuki, represents the culmination of Zen.

The basic doctrine of this *sutra* is embodied in the statement that the absolute Buddha-nature (*Dharmakaya*) and the world of individual phenomena are coexistent and interdependent or — that they are in a state of reciprocal relationships and interpenetration. In Suzuki's words, the sutra "makes everything it depicts transparent and luminous, for luminosity is the only possible earthly representation that conveys the idea of universal interpenetration."[42] The point is, however, that here the all-inclusive unity of *Dharmakaya* does not rob the phenomena of their individual character. Instead, what we have is a thought somewhat similar to the Hegelian conception of concrete universals: "Each individual reality, besides being itself, reflects in it something of the universal, and at the same time it is itself, because of other individuals."[43] The *Avatamsaka* illustrates the meaning of interpenetration by the analogy of a burning candle, surrounded on all sides by mirrors that reflect in a perfect interplay of lights the central light of the candle and the light as reflected by the other mirrors.

The state of interpenetration is equivalent to the Mahayanist *Alaya-vijnana* — "all-conserving mind" or "stored consciousness" that lies behind our ordinary consciousness. The aim of Zen discipline is the unification of this bedrock of our being with individually manifested consciousness. In the process, our sense of an isolated ego surrounded by an alien world gradually melts away. What ensues is an effortless and

desireless life of stillness in the midst of the most intense comings and goings of all things. As a follower of Lao-tzu would declare: "Just because the axle moves not, the spokes revolve."

Alaya-vijnana, according to Suzuki, is "mind in its deepest and most comprehensive sense; while it manifests itself as individualized in our empirical consciousness, it never loses its identity and eternality."[44] In terms of Jungian thought, the universal mind is the repository of archetypes and mythical imagery where all dualisms are suspended. The *Alaya,* as Suzuki describes it, also corresponds to the transpersonal or the basic ground which, in our states of "normal neurosis," we can perceive only literally as the world of names and forms.

Buddhists have called this ground "primordial awareness," "original mind" or "no-mind."[45] No-mindedness refers not to vacuity of mind, but rather to its ubiquity — to a complete openness to experience, unblocked by calculations and deliberations, a pure witnessing and observing of the flow of what "is" without interfering with it, commenting on it, or in any way manipulating it. Directly grasping the world like a child, "man regains his primitive condition, but rather than being unconscious of it, as animals are, he is superconscious of it. It is paradoxical: *by recovering his animal nature, man becomes God.*"[46] In Suzuki's words, a man who has become egoless and desireless is "devoid of all fear, free from all forms of attachments"; his mind "knows no hindrances, no inhibitions, no stoppages, no cloggings. It then follows its own course like water. It is like the wind that bloweth where it listeth."[47]

Even though Suzuki conceives the 'no-mind' in terms of a watery course, it is likely that in traversing Western soil the spontaneous flow would be metanoia-ed into a spiritual ascension, leaving behind (or repressing) all agony and putrefaction. As Hillman sees it, in the West the spirit tends to be "arrow-straight, knife-sharp, powder-dry, and phallic." The notion of spirit "has come to be carried by the Apollonic archetype, the sublimations of higher and abstract disciplines, the intellectual mind, refinements, and purifications."[48] The West

has nearly obliterated the psyche, whose special element is water, the 'patient' and the imagining part of us.[49] But spirit and soul *can* interact and, as we saw, the experience of *satori* seems to represent precisely such an interaction and interpenetration of these two realms.

To temper and to dampen the spirit's flight it is necessary to realize with Hillman that "the psyche does not exist without pathologizing" and that our infirmities and afflictions too connect us with gods. When Jung stated that today "gods have become diseases," he implied, according to Hillman, that "Gods, as in Greek tragedy, *force themselves symptomatically into our awareness*. Our pathologizing is their work . . . "[50] After all, the Gods of the myth are not only perfect but quarreling, cheating, sexually obsessed, revenging, vulnerable, torn apart. There is "sickness in the archetype." The fact that gods are immortal (*athenos*) means that the "*infirmitas* they present is also eternal. Each archetype has a way of leading into death, and thus has its own bottomless depth so causing our sickness to be fundamentally unfathomable."[51]

When Heraclitus stated that "it is by disease that health is pleasant"[52] he was referring to a "hidden harmony" between what our literalizing consciousness perceives as opposites.[53] As an aside, from the viewpoint of "hidden harmony" the Western theological notion of God as the *summum bonum* is not only woefully inadequate but psychically crippling in that it equates God with only one of the fantasies of the soul, i.e., with the spirit. In a Heraclitean and imaginal context, what is truly idolatrous is not polytheism but a strict, image-free monotheism. Hillman has given the best diagnosis so far of the death of the monotheistic God in our time: "If God has died, it was because of his own good health; he had lost touch with the intrinsic *infirmitas* of the archetype."[54]

One of the most important themes in archetypal psychology is the closeness of soul to death. We best enter this final theme by first quoting Rilke, since few people have given such an accomplished expression to that strangest of all coincidences: the correlativity of life and death.

From Myth to Illumination

Death is the *side of life* averted from us, unshone upon by us: we must try to achieve the greatest consciousness of our existence which is at home in *both unbounded realms, inexhaustibly nourished from both* ... The true figure of life extends through *both* spheres, the blood of the mightiest circulation flows through *both: there is neither a here nor a beyond, but the great unity* in which the beings that surpass us, the 'angels,' are at home ... We of the here and now are not for a moment hedged in the time-world, nor confined within it; we are incessantly flowing over and over to those who preceded us ... *We are the bees of the invisible. Nous butinons éperdument le miel du visible, pour l'accumuler dans la grande ruche d'or de l'Invisible.*[55]

In *Suicide and the Soul* Hillman proposes that "the experience of death is requisite for psychic life."[56] Referring to a passage in *Phaedo* (64a) where Socrates speaks of philosophy as the practising of death, Hillman interprets this dying to the world of senses as the dying to the literal perspective which is necessary "to encounter the realm of the soul. . . ."[57] Experience of death acquaints us with "the very first metaphor of human existence: that we are not real."[58] We are not real to the precise extent that we deny our dependence on psychic reality. We are not real because we are reflections of the imaginal psyche; we are shadows of "shadows," i.e., in our literalness — as concoctions of "spirit" and "matter" — we are shadows of our souls. Only soul (the imaginal realm) is not reducible to anything else and so constitutes our true, ontological reality. For the "underworld" of the psyche is "a place where there are only psychic images. From the Hades perspective *we are our images.*"[59]

These are extraordinary lines! Instead of viewing death as an exogenous event, befalling us from outside, Hillman has chosen to see it as something inherently, inalienably human, indeed as "the side of life averted from us" (Rilke). Death nourishes us via the imaginal soul: life would have, literally, no substance without the experience of death. In Hillman's view, therefore, death is the end of life only in a literal sense; imagistically or from the soul's perspective, death is the beginning of life as well. It is all *radically relative:* to the extent that we are afflicted with literalism, we are dead in life, in fact — more dead in life than in death. In the words of Heraclitus: "it is always one

and the same thing that lives in us: living and dead, waking and sleeping, young and old. For the former turns into the latter, and the latter again becomes the former."[60]

The Psalmist said that we are all mortal like animals (" . . . like all the rest," Ps. 72 [-73]; 89 [-90]; Wis. 7.1.; 9.14; 15.17) It would be truer to say, however, that *unlike* animals we are mortal. For animals "and all the rest" are indeed immortal in that they live exclusively in the visible and even though they expire (cease to be), they have lived an immortal life, an eternal moment. The God of monotheism and speculative theology, God as the spirit-fantasy of the soul is also "immortal" (. . . but he died from immortality). Only man is mortal in an ontological way; insofar as he is not *in* the middle between life and eath, but he is this middle itself. Soul in archetypal psychology, unlike the Aristotelian reason, is not something *added* to man, elevating him above the mere vegetative level or making him into an immortal animal.

Soul is imagination. Barfield has stated that imagination as a Western concept is "potentially extraordinary consciousness *present with* ordinary consciousness."[61] I take it to mean that imagination is a *mediatrix*, a Middle Way, working, as with the Romantics, in the manner of the Aeolian lyre in which the wind, blowing through its strings, becomes spirit. However, the spirit, because of the omnipresence of imagination, does not cease to be wind. It is a *samsaric* and imaginal kind of spirit, indissolubly married (for better, not worse) to the soul; not identical with the soul precisely because fully immanent in it; an immortal spirit precisely because it is mortal. Imagination is the premonition of a finite, a Western, infinitude.

NOTES

Introduction: The Forgotten 'Third'

The Collected Works of C.G. Jung, trans. by R.F.C. Hull, have been published in the United States by the Bollingen Foundation (Bollingen Series XX). Since 1967, the American publisher has been the Princeton University Press. The volumes are referred to herein as *CW.*

1. See Chögyam Trungpa, *The Myth of Freedom and the Way of Meditation* (Berkeley and London: Shambala, 1976), p. 69; also pp. 24, 26, 117.

2. David L. Miller, "Orestes: Myth and Dream as Catharsis," *Myths, Dreams, and Religion,* ed. Joseph Campbell (New York: Dutton, 1970), p. 38.

3. *CW* 5, ¶ 20-21.

4. *CW* 12, ¶ 12, 126.

4. *CW* 12, ¶12, 126.

5. *CW* 11, ¶ 773; f. ¶ 770-775.

6. James Hillman, *Re-Visioning Psychology* (New York: Harper & Row, 1975), p. 67.

7. Ananda K. Coomaraswamy, *Hinduism and Buddhism* (New York: Philosophical Library, n.d.), p. 63.

8. Edward Conze, *Buddhism: Its Essence and Development* (Harper Torchbooks, 1959), p. 136.

9. ibid., p. 129.

10. Philip Wheelwright, *Heraclitus* (New York: Atheneum, 1964), Fr. 26.

11. Heinrich Zimmer, *Philosophies of India* (New York: Meridian Books, 1957), pp. 79, 80.

12. Henry Corbin, "*Mundus Imaginalis* or The Imaginary and the Imaginal," *Spring 1972,* p. 15; cf. p. 7; "The *Imago Templi* and Secular Norms," *Spring 1975,* p. 165; *Creative Imagination in the Sufism of Ibn Arabi* (Princeton: University Press, 1969), Chapter IV on "Theophanic Imagination and Creativity of the Heart," p. 216. On Hillman's divergence from Corbin's use of "the imaginal" see Hillman, "On the Necessity of Abnormal Psychology," *Eranos* 43-1974 (Leiden: E.J. Brill), p. 94n.

Notes

13. Hillman, *Re-Visioning Psychology*, pp. 66-68.

14. See Hillman, "Peaks and Vales; the Soul/Spirit Distinction as Basis for the Differences between Psychotherapy and Spiritual Discipline," *On the Way to Self-Knowledge*, ed. Jacob Needleman and Dennis Lewis (New York: Knopf, 1976), pp. 135-136; "On the Necessity of Abnormal Psychology," p. 135.

15. Hillman, *Re-Visioning Psychology*, pp. 67-68.

16. The best historical treatments of imagination are: M.W. Bundy, "The Theory of Imagination in Classical and Medieval Thought," *University of Illinois Studies in Language and Literature* XII (Urbana, 1927), pp. 3-284; Mary Warnock, *Imagination* (Berkeley: University of California Press, 1976). Warnock covers philosophical theories of imagination from Hume to Sartre and Wittgenstein. An outstanding phenomenological treatment of imagination, unique in its field, is Edward S. Casey's *Imagining: a Phenomenological Study* (Bloomington: Indiana University Press, 1976). Some of the gaps in these works may be filled with Paul O. Kristeller's *Eight Philosophers of the Italian Renaissance* (Stanford, Calif.: Stanford University Press, 1964). See also E. Casey's stimulating essay "Toward Archetypal Imagination," *Spring 1974*, pp. 1-32.

17. See Norman O. Brown, *Life Against Death* (Middletown: Wesleyan University Press, 1959), pp. 55-56.

18. Mary M. Watkins, *Waking Dreams* (New York: Harper Colophon Books, 1976), pp. 5-6. A typical example of a negative valuation of the imaginal is Hobbes' theory of imagination as decaying sense; it can be found in Part I, Chap. II of *Leviathan* and in Chap. III of *Human Nature* where he defines imagination as "the conception remaining and by little and little decaying from and after the act of sense." The two passages are from Vols. III and IV respectively of the *English Works of Thomas Hobbes*, ed. Molesworth (London, 1839).

19. Hillman, *The Myth of Analysis: Three Essays in Archetypal Psychology* (New York: Harper Colophon Books, 1978), p. 16 f.; cf. "The Dream and the Underworld," *Eranos* 42-1973, p. 250.

20. See Casey, *Imagining*, pp. 10-14.

21. I. Kant, *Critique of Pure Reason*, A 78-B 103; Kemp-Smith (New York: St. Martin's Press, 1929), p. 112.

22. Martin Heidegger, *Kant and the Problem of Metaphysics*. Tr. by James S. Churchill (Bloomington: Indiana University Press, 1962), p. 170; cf. p. 170n, 175.

23. Heidegger, *Die Frage nach dem Ding. Zur Kantischen Lehre von der transcendenten Grundsätzen* (Tübingen, 1962), p. 117f.

24. Owen Barfield, *Worlds Apart* (Middletown: Wesleyan University Press, 1963), pp. 21-22. In a similar context Hillman has observed that in academic psychology "under the guise of scientific objectivity, myopic subjectivity reigns" ("Preface," *Timeless Documents of the Soul*. a volume from the *Studies from the C.G. Jung Institute, Zürich* (Evanston: Northwestern University Press, 1968), p. ix.

25. David Hume, *Treatise of Human Nature*, I. IV. vii.

Notes

I: Western Romanticism and the East

1. According to Gilbert Durand, the Romantics (Goethe, Novalis, Schlegel, Blake) are part of the "occult tradition" or "antiphilosophy" which includes men like Paracelsus, Angelus Silesius, Cornelius Agrippa, Robert Fludd, Giordano Bruno, Pico della Mirandola, Tauler, Suso, Marsilio Ficino, Nicholas of Cusa, etc. They are all seen as rebels against the dominant Western logic of either/or and the "schizomorphic structure of Western intelligence." ("The Image of Man in Occult Tradition," *Spring 1976*, p. 84; cf. p. 89.) Durand states that "the basic disease from which our culture may be dying is man's minimization of images and myths, as well as his faith in a positivist, rationalist, aseptized civilization" ("Exploring the Imaginal," *Spring 1971*, p. 84.)

2. Casey, *Imagining*, p. 18; cf. his "Toward an Archetypal Imagination," *Spring 1974*, pp. 1-32.

3. S.T. Coleridge, *Biographia Literaria*, Chap. XIII. For a lucid treatment of the problem of poetic imagination with important references to Coleridge, see D.G. James, *Scepticism and Poetry: An Essay on the Poetic Imagination* (London: Allen and Unwin, 1937).

4. *Conversations with Goethe*, recorded by Johann Peter Eckermann, entry dated October 29, 1823. An English translation is published in Everyman's Library.

5. See Coleridge, *Biographia Literaria*, Chap. XIII.

6. See Barfield, *Romanticism Comes of Age* (London: Anthroposophic Pub. Co., 1944), pp. 27-28.

7. Wheelwright, *Heraclitus*, Fr. 42.

8. Bruno Snell, *The Discovery of Mind* (Cambridge: Harvard University Press, 1953), p. 17.

9. See Barfield, *The Rediscovery of Meaning and Other Essays* (Middletown: Wesleyan University Press, 1977), pp. 29-31, 123.

10. ibid., pp. 60-61

11. ibid., p. 30.

12. Warnock, *Imagination*, p. 202. E. Casey speaks about the "possibilizing" power of imagination. "Mind is free — is indeed most free — in imagining." (*Imagining*, p. 201).

13. Barfield, *The Rediscovery of Meaning*, p. 148.

14. ibid., p. 150.

15. L. Lévy-Bruhl, *La Mentalité primitive*, 14th ed. (1947), p. 17.

16. Lévy Bruhl, *La Mentalité primitive* (The Herbert Spencer Lecture, 1931), p. 21.

17. E.E. Evans-Pritchard, *The Theories of Primitive Religion* (Oxford: Clarendon Press, 1965), p. 91; cf. pp. 86-92. In opposition to Lévy-Bruhl's evolutionary conception of prelogical mentality, Bronislaw Malinowski emphasizes the functional significance of myth: "Studied alive, myth . . . is not symbolic, but a direct expression of its subject matter; it is not an explanation in satisfaction of a scientific interest, but a narrative resurrection of a primeval reality, told in satisfaction of deep religious wants, moral cravings, social submissions . . . Myth is a vital ingredient of human civiliza-

Notes

tion; it is not an idle tale, but a hard-worked active force; it is not an intellectual explanation ... but a pragmatic charter of primitive faith and moral wisdom." (*Magic, Science and Religion*, Garden City, N.Y.: Doubleday & Co., 1948, p. 101.)

18. Barfield, *The Rediscovery of Meaning*, p. 75.

19. Quoted in Barfield, ibid., p. 67.

20. Barfield, *Speaker's Meaning* (Middletown: Wesleyan University Press, 1967), pp. 113-114. Cf. *Rediscovery of Meaning*, pp. 17, 148-149; *Saving the Appearances, A Study in Idolatry* (New York: Harcourt, Brace and World, 1965), Chapters I-X.

21. I am referring to the circle of *Hermes Trismegistus* (Hermes Thrice-Greatest) who defined God as "an intelligible sphere whose center is everywhere and whose circumference is nowhere." In the Middle Ages this definition was attributed to Plato, it was repeated by Rabelais, Bruno, Nicholas of Cusa, Pascal, and lately by Jung in his conversations with Hermann Hesse. See *Liber XXIV philosophorum*, Proposition II; Clemens Baumker, "Das pseudo-hermetische Buch der vierundzwanzig Meister' [...]," *Abhandlungen aus dem Gebiete der Philosophie und ihrer Geschichte*. Festgabe zum 70. Geburtstag Georg Freiherrn von Hertling (Freiburg im Breisgau: Herder, 1913), p. 31.

22. Quoted in Warnock, *Imagination*, p. 66. Howard Nemerov who writes in the spirit of Barfield, says that "poetry ... attempts to catch the first evanescent flickerings of thought across the surface of things. It wants to be as though the things themselves were beginning to speak." Poetry is "simply language doing itself right, language as it ought to be, language as it was in the few hours between Adam's naming the creation and his fall." *Figures of Thought* (Boston: David R. Godine, 1978), pp. 11, 57.

23. Barfield, *Rediscovery of Meaning*, p. 16.

24. ibid., p. 30; cf. p. 24.

25. Hillman, *Re-Visioning Psychology*, p. 173.

26. Hillman, *Loose Ends: Primary Papers in Archetypal Psychology* (Zürich: Spring Publications, 1975), p. 3. In this respect Hillman follows Neo-Platonists who did not distinguish between *my* soul and *the* soul; also Jung who consistently views soul as an impersonal archetype, as an *a priori* which is universal in scope (*CW* 16, ¶ 469). Besides Hillman, who is the main proponent of archetypal psychology, others who write (mainly in the annual *Spring*) in this area are: Patricia Berry, the late Evangelos Christou, Adolf Guggenbühl-Craig, Rafael Lopez-Pedraza, Edward Casey, David L. Miller, etc.

27. Hillman, "On the Necessity of Abnormal Psychology," *Eranos* 43-1974 (Leiden: E.J. Brill), p. 95. Cf. *Loose Ends*, p. 180; 142-143; "The Dream and the Underworld," *Eranos* 42-1973, pp. 274, 285. Contrary to evolutionism, says Hillman, "myths are not explanations ... they are stories, as our fantasies are, which project us into participation with the phenomena they tell us about so that the need for explanation falls away." (*The Myth of Analysis*, p. 202; cf. pp. 195-202.)

28. Hillman, "The Dream and the Underworld," p. 256; cf. C.G. Jung

Notes

and K. Kerényi, *Essays on a Science of Mythology* (Princeton: University Press, 1963).
 29. Hillman, *The Myth of Analysis*, p. 267.

II: Imagination in Jung and Hillman

 1. Hillman, *Suicide and the Soul* (1964) (Zürich: Spring Publications, 1976), p. 46; cf. *Insearch: Psychology and Religion* (New York: C. Scribner's Sons, 1967), p. 42. Because the word "psyche" is a symbol, we cannot find out what it means by going back to an etymological origin. Psyche is the subject of our experience that can be defined. As Jung says: " . . . the psyche is the object of psychology, and — fatally enough — its subject at the same time . . . " (*Psychology and Religion*. New Haven: Yale University Press, 1939, p. 62. Among the standard works on the subject is E. Rhode's classic *Psyche*, trans. W.B. Hillis, 8th ed. London, 1925.
 2. Hillman, *Re-Visioning Psychology*, p. x.
 3. Hillman, "The Fiction of Case History: a Round," *Religion as Story*, ed. James B. Wiggins (New York: Harper & Row, 1975), p. 161; cf. *Suicide and the Soul*, p. 98.
 4. See Hillman, *Re-Visioning Psychology*, pp. 174, 162.
 5. The Latin word "numinous" originally refers to the animation of an image in a polytheistic context and not to the God of the Old Testament as R. Otto had presumed. See Hillman, "Pandämonium der Bilder: C.G. Jungs Beitrag zum 'Erkenne dich selbst', " *Eranos* 44-1975 (Leiden: E.J. Brill), p. 440. The image, far from representing something, is in Wallace Stevens' words "the essential poem at the centre of things" (*The Collected Poems of Wallace Stevens*. New York: A.A. Knopf, 1978), p. 440, "A Primitive Like an Orb."
 6. *CW* 6, ¶ 78; cf. ¶ 77; 11, ¶ 889.
 7. W.M. Roscher and James Hillman, *Pan and the Nightmare* (Zürich: Spring Publications, 1970), p. xxv; cf. Hillman, "Why Archetypal Psychology?" *Spring 1970*, p. 216.
 8. Hillman, "The Fiction of Case History: a Round," p. 159; cf. "Peaks and Vales," p. 118; *Re-Visioning Psychology*, p. xv; Susanne K. Langer, *Feeling and Form: A Theory of Art* (New York: C. Scribner's Sons, 1953), Chap. 13; *Problems of Art* (New York: C. Scribner's Sons, 1957), Chap. 10.
 9. See Hillman, *The Myth of Analysis*, p. 176f.; *Re-Visioning Psychology*, p. xi; *Pan and the Nightmare*, p. xxv; "Pandämonium der Bilder," *Eranos* 44-1975, p. 422n.
 10. *CW* 11, ¶ 769.
 11. Hillman, "Peaks and Vales," p. 118. From the point of view of psychology all statements are "*true positions, in that they are statements about the soul made by the soul* "(*Suicide and the Soul*, p. 46.)
 12. Hillman, *Re-Visioning Psychology*, p. 23. In addition to imagination as a distinct faculty of the soul, Jungian literature abounds in references to "active imagination." The latter was developed by Jung and must be

Notes

distinguished from the Freudian technique of "free association." The method of free association is based on the premise that all significant imagining represents the fulfillment of certain infantile wishes. Active imagination, on the contrary, is a purposive turning to the transpersonal unconscious which is not only the basis of the conscious mind, but also the subjective or inner aspect of nature. In active imagination we are expected to recognize the "otherness" and the genuine autonomy of an objective impersonal psyche. The images which appear during this activity, must be allowed to speak for themselves, to have a life of their own; the ego's task is to be an onlooker and at the same time to be involved — akin to the attitude of a playgoer watching a moving stage drama. Eventually one is led to experience a new level of being — a world in which the ego participates not as director, but as the actively experiencing one. Active imagination must be also distinguished from the ordinary conscious imagining or mere fancy, day-dreams and reveries which Jung ranges under the rubric of "passive fantasy" and which is dominated by the imaginer's ego. In these pages I use the word "imagination" in an inclusive sense, i.e., as a specific faculty of the human mind which may or may not be employed "actively". In any event, "active imagination" is continuous with imagination *tout court* or, if one prefers, with "true imagination" (*vera imaginatio* of the alchemists). For references see R.F.C. Hull, "Bibliographical Notes on Active Imagination in the Works of C.G. Jung," *Spring 1971*, pp. 115-120.

13. *CW* 9, i, ¶ 56; cf. 13, ¶ 57; 9, i, ¶ 119; 13, ¶ 126, 223; 9, ii, ¶ 24; 6, ¶ 78.

14. *CW* 6, ¶ 745 (italics mine); cf ¶ 743.

15. See *CW* 6, ¶ 80; 11, ¶ 553-555; cf. Edward F. Edinger, *Ego and Archetype* (Baltimore: Penguin Books, 1972), p. 111.

16. Kathleen Raine, *Defending Ancient Springs* (Oxford University Press, 1967), p. 113.

17. *CW* 13, ¶ 54, translation mine.

18. Patricia Berry, "An Approach to the Dream," *Spring 1974*, p. 67.

19. *CW* 8. ¶ 402; cf. 12, ¶ 329; 17 ¶ 162. Hillman sees the difference between Freud and Jung in terms of difference between allegory and metaphor. Both "start off saying one thing as if it were another. But where allegorical method divides this double talk into two constituents — latent and manifest — the metaphorical method keeps the two voices together, hearing the dream as it tells itself, ambiguously evocative and concretely precise at each and every instant. Metaphors are not subject to interpretative translation without breaking up their peculiar unity" ("The Fiction of Case History: a Round," p. 157).

20. Hillman, "An Inquiry into Image," *Spring 1977*, p. 68, italics mine.

21. ibid., p. 87. Tibetan Tantric Buddhism uses *mantras* (often a meaningless string of sounds) to point beyond themselves to nothing or the Void, as in poetry when the meaning or effect of a line is less important than its musical or evocative qualities. A proper use of *mantra* releases within each person latent forces which are normally suppressed by the ego.

Notes

22. Aldous Huxley, *The Perennial Philosophy* (New York: Harper & Row, 1944), pp. 72-73.

23. Jung, *Memories, Dreams, Reflections*. ed. by Aniela Jaffé. Trans. by Richard and Clara Winston (New York: Vintage, 1963), p. 297.

24. *CW* 12, ¶ 396.

25. Henry Corbin, "*Mundus Imaginalis* or the Imaginary and the Imaginal," *Spring 1972*, p.9; cf. pp. 7, 15.

26. Watkins, *Waking Dreams*, pp. 144-145.

27. See Hillman, "Peaks and Vales," p. 117; cf. *CW* 6, ¶ 80.

28. *CW* 13, ¶ 54; cf. Hillman, *Re-Visioning Psychology*, p. 14.

29. Barfield, *Saving the Appearances*, pp. 126, 132.

30. Hillman, *Insearch*, p. 79.

31. Hillman, *Loose Ends*, p. 142.

32. *ibid.*, p. 143.

33. Hillman, "The Feeling Function," Marie-Louise von Franz and James Hillman, *Jung's Typology* (Zürich: Spring Publ., 1971), p. 148.

34. *CW* 13, ¶ 299; cf. 9, ii, ¶ 4; Hillman, *Loose Ends*, p. 180.

35. *CW* 9, i, ¶ 261; cf ¶ 262, 263, 267; 8, ¶ 330 f.

36. Hillman, *Re-Visioning Psychology*, p. 151.

37. Hillman, *Loose Ends*, p. 142.

38. See ibid., p. 183; *Re-Visioning Psychology*, p. 23.

39. *CW* 11, ¶ 845; cf. 6, ¶ 77, 733-736.

40. *CW*, 8, ¶ 402; cf. 12, ¶ 329.

41. Stephanie de Voogd, "C.G. Jung: Psychologist of the Future, Philosopher of the Past," *Spring 1977*, pp. 180-181. It has been suggested that Jung's mature formulation of the archetype can be understood analogously to the concept of form and field in post-Einsteinian science which has replaced the Aristotelian notion of the procession of forms by the notion of the *forms of process*. See P. Dechamps, *La formation de la pensée de Coleridge* (Paris, 1964). "Field" can be defined as configuration of potential energy, as a form-potential that becomes actual and manifest in the visibility of material things. "Form or shape as the a priori organizing potential rather than the shape of a material 'thing' becomes the *basic unit of existence*. These forms without content incarnate themselves, move from potentiality into actuality by manifestation through, or rather as, matter." — Jung's "archetype" is also similar to "Gestalt" in Gestalt psychology where form is the primary unit of functioning: both archetype and Gestalt are primary form-dynamics; our perceptions are patterned from the beginning in terms of whole Gestalts. Thus "imaginal or symbolic thinking, i.e., imagining, the experiencing of form patterns or configurational wholes is ... an inner expression of our oneness with outer reality. The form-dynamics of the psyche interact with its analogon in external reality" (Edward C. Whitmont, "Nature, Symbol, Imaginal Reality," *Spring 1971*, p. 69). In short, Jung's concept of the archetype *per se* and its manifestation as image would correspond to the fields of pure forms and their visibility in matter.

42. See Casey, "Toward an Archetypal Imagination," *Spring 1974*, p. 22; Hillman, *Re-Visioning Psychology*, p. 157.

43. Hillman, "An Inquiry into Image," *Spring 1977,* p. 75.
44. ibid., pp. 62, 64.
45. Patricia Berry, "An Approach to the Dream," pp. 63, 64.
46. Hillman, "An Inquiry into Image," p. 80; cf. *The Myth of Analysis,* p. 197.
47. Hillman, "On the Necessity of Abnormal Psychology," p. 103; cf. "An Inquiry into Image," pp. 82-83; p. 85; "Further Notes on Images," *Spring 1978,* p. 173.
48. Hillman, "On the Necessity of Abnormal Psychology," p. 95n.
49. ibid., p. 104.
50. Hillman, "Further Notes on Images," p. 152.
51. *CW* 6, ¶ 743.
52. Hillman, "Further Notes on Images," pp. 170-171.

III: Mythical Imagination — Cassirer and Depth Psychology

1. *CW* 9, i, ¶ 291.
2. See David Bidney, "On the Philosophical Anthropology of Ernst Cassirer and Its Relation to the History of Anthropological Thought," *The Philosophy of Ernst Cassirer,* ed. Paul Arthur Schilpp (La Salle, Ill.: Open Court Pub. Co., 1949), pp. 467-544.
3. Ira Progoff, *Jung's Psychology and Its Social Meaning* (Garden City, N.Y.: Doubleday, 1973), pp. 241-242.
4. Susanne K. Langer, "On Cassirer's Theory of Language and Myth," *The Philosophy of Ernst Cassirer,* p. 395.
5. See Ernst Cassirer, *The Philosophy of Symbolic Forms* (New Haven: Yale University Press, 1944), Vol. 1: 228.
6. ibid., p. 107.
7. ibid., p. 111; cf. pp. 74, 76-79; *Language and Myth* (Dover Publications, 1953), pp. 8-9.
8. Cassirer, *An Essay on Man* (New Haven: Yale University Press, 1962), p. 25; cf. p. 26f.
9. Hillman, "Peaks and Vales," p. 118.
10. Hillman, *Re-Visioning Psychology,* pp. 152-153.
11. See Cassirer, *The Philosophy of Symbolic Forms,* Vol. 1: 84; cf. Vol. 3: 385.
12. See Naomi R. Goldenberg, "Archetypal Theory After Jung," *Spring 1975,* pp. 213, 217.
13. Patricia Berry, "On Reduction," *Spring 1973,* p. 83; cf. p. 73.
14. See Cassirer, *Philosophy of Symbolic Forms,* Vol. 3: 158; *Language and Myth,* p. 58. Susanne Langer, in agreement with Gestalt psychologists, elaborates on this idea by saying that our sense experience is already a process of *formulation.* Our senses do not meet a world of "things"; they rather select out of this world certain predominant forms. The eye and the ear have their own logic, their "categories of understanding" (Kant) or what Coleridge called "Primary imagination." This

Notes

"unconscious" apparition of forms is the primitive root of all abstraction and rationality. To Langer and by extension to Cassirer *nihil est in homine quod non prius in amoeba erat* which is to say that "the conditions for rationality lie deep in our pure animal experience — in our power of perceiving, in the elementary functions of our eyes and ears and fingers. Mental life begins with our mere physiological constitution." This psychological insight which goes back to the school of Wertheimer, Köhler, and Koffka, has important philosophical implications: " . . . it carries rationality into processes that are usually deemed pre-rational, and points to the existence of forms, i.e., of *possible symbolic material*, at the level where symbolic activity has certainly never been looked for by any epistemologist." *Philosophy in a New Key* (Cambridge: Harvard University Press, 1942, pp. 91, 89, 90, 28). Langer is correct in reducing "rationality" to "possible symbolic material," but, like Cassirer, she is unable to reduce it even further to the imaginal since it would imply the admission of the Jungian *esse in anima* and a consequent collapse of her evolutionistic and rationalistic bias.

15. *CW* 9, i, ¶ 291; cf. 10, ¶ 13.

16. Cassirer, *An Essay on Man*, p. 31; cf. pp. 33, 36-37; *CW* 18, ¶ 481-482; 7, ¶ 492.

17. Cassirer, *The Philosophy of Symbolic Forms*, Vol. 1: 85; cf. p. 87; Vol. 2: 385; *CW* 6, ¶ 178; 9, ii, ¶ 28; 13, ¶ 199; 14, ¶ 764, 768, 705.

18. Cassirer, Vol. 1: 111.

19. ibid., p. 113; cf. Vol. 3: 40.

20. Cassirer, *An Essay on Man*, p. 154; cf. p. 164.

21. T.S. Eliot, when asked, "Please, Sir, what do you mean by the line 'Lady, three white leopards sat under the juniper tree?' " replied "I mean Lady, three white leopards sat under the juniper tree . . ." Stephen Spender, "Remembering Eliot," *Encounter, XXIV, April 1965, 4).*

22. Cassirer, *An Essay on Man*, p. 161.

23. During the transition from the mythical thought to a religious world view, which will be discussed later, images become re-presentations, i.e., symbols of a 'transcendent' reality. See Cassirer, *The Philosophy of Symbolic Forms*, Vol. 1: 239, 253. Hillman associates this process with "depotentiation" of images.

24. *CW* 11, ¶ 469; cf. Cassirer, *The Philosophy of Symbolic Forms*, Vol. 3: 15f.

25. Cassirer, *The Philosophy of Symbolic Forms*, Vol. 2, 13-23; cf. p. xv; Vol. 3: 49; Langer, *Philosophy in a New Key*, pp. 97, 143.

26. *CW* 11, ¶ 240.

27. See Cassirer, *An Essay on Man*, pp. 81, 86, 94.

28. Cassirer, Vol. 2: 235.

29. ibid., p. 200.

30. See ibid., pp. 40-42.

31. Henri Frankfort et al., *Before Philosophy; the Intellectual Adventure of Ancient Man* (Baltimore: Penguin Books, 1967), p. 21.

32. Langer, "On Cassirer's Theory of Language and Myth," p. 388; cf. Cassirer, *Language and Myth*, pp. 91-92.

Notes

33. Frankfort has pointed out that ancient man experienced the world emotionally "in dynamic reciprocal relationship . . . he simply does not know an inanimate world. For this very reason he does not 'personify' inanimate phenomena nor does he fill an empty world with the ghosts of the dead, as 'animism' would have us believe." The primitive could reason logically, but most of the time he did not care to do it. "The 'logic,' the peculiar structure, of mythopoeic thought can be derived from the fact that the intellect does not operate autonomously because it can never do justice to the basic experience of early man, that of confrontation with a significant 'Thou'. Hence when early man is faced by an intellectual problem within the many-sided complexities of life, emotional and volitional factors are never debarred; and the conclusions reached are not critical judgment but complex images." (*Before Philosophy,* p. 14; cf. pp. 35-36.)
34. Cassirer, *The Philosophy of Symbolic Forms,* Vol. 3: 72; cf. *An Essay on Man,* pp. 82-83. Mircea Eliade, *Myth and Reality,* trans. by Willard R. Trask (New York: Harper & Row, 1963), p. 139.
35. ibid., p. 78.
36. Cassirer, Vol. 2: pp. 211-218; cf. pp. 156; 205-206; Vol. 3: 71; Vol. 1: 249f.; *The Logic of Humanities,* tr. by Clarence Smith Howe (New Haven: Yale University Press, 1961), pp. 188-189.
37. Hillman, *Re-Visioning Psychology,* p. 12.
38. ibid., p. 2.
39. Walter F. Otto, *Mythos und Welt* (Stuttgart: Klett, 1962), p. 261. Hillman's translation, quoted in *Re-Visioning Psychology,* p. 17.
40. James Frazer, *The Golden Bough.* 1 Vol. abridged ed. (New York: Macmillan Co., 1934), p. 690; cf. p. 179. The idea of the multiple souls is central in the Greek shamanistic tradition and survived in varying forms well into the Classical Age. See E.R. Dodds, *The Greeks and the Irrational* (Berkeley: University of California Press, 1951), Chapter 5.
41. Hillman, *Re-Visioning Psychology,* pp. 13, 15.
42. ibid., p. 157; cf. "An Inquiry into Image," pp. 67-68.
43. Berry, "An Approach to the Dream," p. 61. In Jung, image is not a psychic reflection of an external object, but a concept derived from poetic usage, i.e., a fantasy-image, see *CW* 6, ¶ 743.
44. Hillman, "The Dream and the Underworld," p. 273.
45. Hillman, *Re-Visioning Psychology,* p. 134.
46. Evangelos Christou, *The Logos of the Soul* (1963) (Zürich: Spring Publications, 1976), p. 7
47. ibid., pp. 36; 37; 31.
48. See *Enneads,* IV, 8, 7, trans. by E.R. Dodds in *Select Passages Illustrating Neoplatonism* (London: SPCK, 1960).
49. Paraphrase by P.O. Kristeller in *Eight Philosophers of the Italian Renaissance* (Stanford: Stanford University Press, 1964), p. 43.
50. See *Timaeus* 35A, 90A, Cornford's translation. For a thorough discussion of Plato on this point, see F. Cornford, *Plato's Cosmology* (London: Routledge, 1952), pp. 59-66.
51. Hillman, *The Myth of Analysis,* p. 66. cf. p. 70.
52. Hillman, *Re-Visioning Psychology,* pp. x; 68. The key passages in

Notes

Jung, associating *anima* as reflective instinct, with the basis of consciousness, are *CW* 8, ¶ 242; 11, p. 158n.

53. Hillman, "Anima (II)," *Spring 1974*, p. 127. On *metaxis* as the "place" of Socratic Eros and the soul's relation to Eros, see Hillman, *The Myth of Analysis*, Chapter I, "On Psychological Creativity."

54. Hillman, *The Myth of Analysis*, p. 71.

55. Hillman, "Anima," *Spring 1973*, p. 119.

56. *CW* 9, i, ¶ 57.

57. Hillman, "Anima," *Spring 1973*, p. 119.

58. Zimmer, *Philosophies of India*, p. 600; cf. pp. 574-575; 460-461. What Zimmer means by "Mother of the World" in Hinduism is not "The Great Mother" of Erich Neumann or the Greek *Ge* (Roman *Tellus);* the Hindu concept is more akin to *chthon* and Hades — the Underworld which Hillman distinguishes from the "underground" and which he identifies with shallow materialism. "Chthonic man is not natural man, but psychic man ... " See "The Dream and the Underworld," p. 267; cf. pp. 267-281.

59. Kathleen Raine, *Blake and the Tradition*, Vol. 2 (Princeton: Princeton University Press, 1968), Chapter 24: "Jesus the Imagination."

IV: That "We Are Not Real"

1. Hillman, *Re-Visioning Psychology*, pp. 22; 32; 24.

2. *CW* 13, ¶ 51; cf. "On the Nature of the Psyche," *CW* 8, where Jung discusses "the dissociability of the psyche" (p. 173f) which in turn provides ground for his hypothesis of the "unconscious as a multiple consciousness" (p. 190f); Hillman, *The Myth of Analysis*, pp. 164-169.

3. Hillman, *Re-Visioning Psychology*, p. 26.

4. See Wheelwright, *Heraclitus*, p. 120, no. 3; cf. fr. 26.

5. Hillman, *Re-Visioning Psychology*, pp. xvi; 29; 30; cf. pp. xiv, 28.

6. *CW* 13, ¶ 63; 55; cf. ¶ 64-82.

7. Hillman, *Re-Visioning Psychology*, p. 31.

8. ibid., p. 152; cf. p. 15.

9. Hillman, "The Fiction of Case History: a Round," pp. 160-161. "Wholeness of personality means highly complex tension of parts" *(Loose Ends,* p. 182; cr. pp. 171-173.)

10. Hillman, *Re-Visioning Psychology*, pp. 173; 174; 209; cf. p. 181.

11. There is an unnatural collusion between Jung and humanistic psychology; the latter, while recognizing that we are not altogether real at the core of our being, exhorts man to actualize himself. "Ignoring the mythical nature of soul and its eternal urge out of life and toward images, humanistic psychology builds a strong man of frail soul trembling in the valley of existential dread" (Hillman, *Re-Visioning Psychology*, p. 209.)

12. Hillman, *The Myth of Analysis*, p. 182.

13. ibid., pp. 184; 185; cf. *Re-Visioning Psychology*, p. 135.

14. Hillman, *Re-Visioning Psychology*, p. 222; cf. pp. 11, 28, 172, 198, 220.

Notes

15. L.L. Whyte, *The Unconscious Before Freud* (New York: St. Martin's Press, 1978), p. 27.

16. S. Freud, *New Introductory Lectures in Psychoanalysis*, p. 98, trans. W.J.H. Sprott (London: Hogarth, 1933/57). In view of this and other instances where Freud speaks of man's "archaic heritage . . . psychically innate in him" *(Outline of Psychoanalysis*, 24; the Standard Edition of the *Complete Psychological Works* V, 549), Hillman reports Guggenbühl–Craig's observation that "the Freudians cannot properly understand Freud because they take him at his word. Only the Jungians can properly understand Freud because they can read him for his mythology." ("The Dream and the Underworld," p. 250).

17. Graham Parkes calls the Jungian view of the psyche "the container fantasy" and traces its beginning in the philosophies of Descartes and Locke ("Time and the Soul: Heidegger's Ontology as the Ground for an Analytical Psychology." Dissertation, 1978, pp. 66-74. Private copy).

18. See Hillman, *Loose Ends*, p. 141; cf. *The Myth of Analysis*, p. 173 f. In questioning the term, Hillman and others do not deny the existence of certain unconscious processes occurring in human experience, as illustrated by Freud and Jung in such phenomena as forgetting, slips of tongue, dreaming, habit, neurotic symptoms. For an attempt to formulate "the unconscious," which includes a complete review of the problems of the Freudian formulation, see Matte Blanco, *The Unconscious as Infinite Sets* (London: Duckworth, 1975); cf. J.A. Wellwood, "A Theoretical Reinterpretation of the Unconscious from a Humanistic and Phenomenological Perspective." Unpublished doctoral dissertation: University of Chicago, 1974. The most systematic treatment of the unconscious by Jung is in *Two Essays on Analytical Psychology* (*CW* 7); cf. *Man and His Symbols*, ed. C.G. Jung (Dell Pub. Co., 1964), pp. 1-94.

19. Hillman, *Re-Visioning Psychology*, p. 125; cf. p. 141.

20. Hillman, *The Myth of Analysis*, p. 177.

21. Hillman, "Peaks and Vales," p. 118; cf. *The Myth of Analysis*, p. 173.

22. Hillman, "The Dream and the Underworld," p. 272.

23. See *Eranos* 42-1973, pp. 236-321. This lengthy essay, reworked and enlarged, is now widely available in expanded book form under the title *The Dream and the Underworld* (New York: Harper & Row, 1979).

24. Hillman, "The Dream and the Underworld," p. 300.

25. ibid., p. 270.

26. ibid., p. 274.

27. ibid., p. 301.

28. Hillman, *The Myth of Analysis*, pp. 186-187.

29. Hillman, "The Dream and the Underworld," p. 304.

30. See ibid., p. 318.

31. For a detailed and profound discussion of the historical, philosophical and psychological aspects of Zen see D.T. Suzuki, *Essays in Zen Buddhism*, 3 Vols. (New York: Samuel Weiser, Inc., 1958). Cf. Thomas Merton, *Mystics and Zen Masters* (New York: Dell Pub. Co., 1961).

Notes

32. D.T. Suzuki, *Zen and Japanese Culture*, (Princeton: Princeton University Press, 1959), pp. 94-95.

33. Alan Watts, *In My Own Way, An Autobiography* (New York: Vintage Books, 1972), p. 392.

34. Suzuki, *The Zen Doctrine of No-Mind* (New York: Samuel Weiser, Inc., 1977), p. 61.

35. John Wellwood, "Meditation and the Unconscious: a New Perspective," *The Journal of Transpersonal Psychology*, 1977, Vol. 9/1, p. 2; cf. "On Psychological Space," *The Journal of Transpersonal Psychology*, 1977, Vol. 9/2, pp. 97-117; Ken Wilber, "Psychologia Perennis: the Spectrum of Consciousness," *The Journal of Transpersonal Psychology*, 1975, No. 2, pp. 105-132.

36. *CW* 11, ¶ 774.

37. Wellwood, "Meditation and the Unconscious: a New Perspective," p. 4; cf. p. 19; R. De Martino, K. Soto, et al., "What is the True Self? A Discussion," *Psychologia*, 1961, 4, pp. 126-132.

38. It has been suggested that the Jungian collective unconscious could be relocated into the environment and would thus become "an environmental unconscious." This view is based on James J. Gibson's theory that "the process of perception is a continuous interactive relation between the organism and environment" (Charles Boer and Peter Kugler, "Archetypal Psychology is Mythical Realism," *Spring 1977*, p. 134). What happens then is that we "pick up . . . invariant relationships [archetypes] from the environmental unconscious" in the form of myths and make them explicit. The distinctive feature of this theory — called by the authors "mythical realism" — is that "sensation . . . is not a prerequisite for perception" (p. 135). The notion of "sense-perception" is repudiated "in favor of perceptual systems for which the senses are not data processors." (p. 149) Furthermore, it is suggested that the process which *directly* picks up the information stored in the environment, is "intuition" (p. 145). In this view, "there is really no need," according to the authors, "to talk about depths that are not extended in the sense world . . . The depths . . . extend into the environmental unconscious. The depths of the imagination are perceivable . . . in a direct realist way. All is depth, as well as movement" (pp. 149-150). The authors also claim that "mythical realism" goes further than archetypal psychology with its insistence that images cannot be perceived by sense perception, but only imagined (see Hillman, "The Dream and the Underworld," p. 273)

It is difficult to fathom, however, in what way "perceptual systems" or "intuition," as these terms are used by the authors, are essentially different from "imagination." To say that "the depths of imagination are perceivable" seems to amount to a surreptitious attempt to re-introduce the old and ever freshly refurbished reductionism through the back door of archetypal psychology. In my view it is imperative to maintain and to safeguard the notion of the imaginal as the "absolute" middle between the inner and the outer. If the imaginal is replaced by the notion of "perceptual systems" we are in danger of losing soul to the "environment." For to say that "all is depth" is either a form of scientism under the

Notes

guise of pantheism or vice versa, which is not saying very much. On the other hand — and this could be the crux of the matter — the proponents of "direct" or "mythical realism," if I am not mistaken, are trying to express in a 'scientific' way what in certain literary circles, influenced by Heidegger, is known as "antimetaphor" or "absolute metaphor." One of the main advocates of this trend is Beda Allemann who, using Kafka (also Alain Robbe-Grillet) as the primary example, maintains that metaphor, as defined by traditional rhetoric, is dead. Kafka's stories are devoid of metaphor and "thus become a kind of metaphor themselves; this new metaphor, however, is without a definite level of meaning outside of it, a level on which its 'real,' nonfigurative, *eigentliche* meaning may be found" ("Metaphor and Antimetaphor," *Interpretation: The Poetry of Meaning*, ed. Stanley R. Hopper and David L. Miller. New York: Harcourt, Brace & World, 1967, p. 114). Kafka's text is a kind of "absolute metaphor," intended to show that it allows for detection of meaning in a world where traditional references for meaning are absent.

Now if the statement "all is depth" is intended to convey the presence of meaning in the world as a whole in spite of the absence of a divine guarantor of meaning, then again it would be at least methodologically cleaner to assign the power of detection of such pervasive meaning to imagination rather than saying that imagination is *perceived*. Imagination can have this function of "mean-ing" precisely because it is the indispensable middle between all abstractions and literalisms. I would express this by saying that the world as a whole — what's 'out there,' the physical world — is a metaphor whose only *real* referent is imagination.

It would be instructive to compare the thesis of "mythical realism" with M. Merleau-Ponty's abortive attempt to demonstrate the priority of perception to imagination. See Warnock, *Imagination*, pp. 144-149.

39. Trungpa, *Meditation in Action* (Berkeley: Shambala, 1968), p. 52.

40. Herbert V. Guenther and C. Trungpa, *The Dawn of Tantra* (Berkeley: Shambala, 1975), p. 27.

41. See Ernest Becker, *The Denial of Death* (New York: Free Press, 1973), pp. 47-66.

42. Wellwood, "Meditation and the Unconscious," p. 19; cf. pp. 10-11.

43. See Zimmer, *Myths and Symbols in Indian Art and Civilization*, ed. Joseph Campbell (Harper Torchbooks, 1962), pp. 25-26. Cf. Shri Shankaracharya, *Vivekachudamani*. Text in Devanagari with word-for-word translation, English rendering and commentary (by) Swami Madhavananda (Calcutta: Advaita Ashrama, 1970), pp. 93-94; 241-253; 398-404. Hillman has shown that the psychological *what* differs from its background in the phenomenology of Husserl: "Phenomenological reduction becomes an archetypal reversion, a return to mythical patterns and persons" (*Re-Visioning Psychology*, p. 139). Ultimately psychologizing's *what* dissolves into *who?*

44. Trungpa, *The Myth of Freedom*, p. 153.

45. *CW* 9, i, ¶ 634; cf. 11. ¶ 80-82; 13, ¶ 56.

46. Wellwood, "Meditation and the Unconscious," p. 20.

47. Hillman, "Anima," p. 122.

Notes

48. *CW* 8, ¶ 666; cf. ¶ 668-671.

49. *CW* 8, ¶ 671; cf. ¶ 668; 9, i. ¶ 518-519. Hillman envisages *anima* figure, which Jung has tended to limit to the special psychology of men, as "an archetypal structure of consciousness." *Anima* is our link with nature or nature's link with us, the psychic factor in nature, a "moment of reflection" when "life" and its "soul" are abstracted from nature and endowed with a separate existence. In the framework of Cassirer's philosophy, this moment corresponds to the materialization of the first mythical images. *Anima* is likewise a phantasmically dim "consciousness of our fundamental unconsciousness," of the contrary emotions of fascination and danger, awe and desire, life and death, i.e., of all things that are opaque to the conscious focal mind of the 'primitive' as well as the modern man. *Anima* or psychic life within nature is, according to Hillman, analogous with Maya, Shakti, Sophia, etc.; it points to a "kind of life which projects out of itself consciousness." See "Anima," pp. 103, 125, 104, 119.

50. Snell, *The Discovery of Mind*, p. 203.

V: From Myth to Illumination

1. Langer, *Philosophy in a New Key*, p. 88.

2. Hillman, *Re-Visioning Psychology*, p. 9.

3. Barfield, *Rediscovery of Meaning*, p. 15; cf. p. 14.

4. ibid., p. 16.

5. Langer, "On Cassirer's Theory of Language and Myth," p. 386.

6. Edward Sapir, *Encyclopedia of Social Sciences*, Article "Language," p. 159.

7. Cassirer, *The Philosophy of Symbolic Forms*, Vol. 3: 108.

8. Cassirer, *Language and Myth*, p. 58. Bruno Snell points out that "mythical thought is closely related to the thinking in images and similes. Psychologically speaking, both differ from logical thought in that the latter searches and labors while the figures of myth and the images of similes burst fully shaped upon imagination" (*The Discovery of Mind*, p. 224).

9. Langer, "On Cassirer's Theory of Language and Myth," p. 390.

10. Cassirer, *Language and Myth*, p. 58.

11. *Taittiriya Brahm.*, 2, 8, 4. According to Paul Thieme, the word *brahman* in the Vedic texts usually stands for "poetic formation" (*dichterische Formulierung*) expressing the essential being of language ("Brahman," *Zeitschrift der Deutschen Morgenlandischen Gesellschaft*, 101/2 (1952), pp. 113-115. The *Rgveda* says that "as far as *brahman* reaches, so reaches speech" (10. 114. 8). Evidently the creative power of *brahman* is attributed to speech as well. There is a hymn in the *Rgveda* devoted entirely to speech. Speech (*vak*) is here a Goddess who narrates:

> I span the bow for Rudra, so that his arrow will kill the enemy of poetic formulation. I cause strife among the people. I enter heaven and earth.

Notes

> At the summit of the earth I brought forth the father. My origin is in the waters, in the ocean. From there I extend over all worlds. I touch even yonder heaven with my height.

> I blow forth like the wind. I hold fast all worlds. Wider than the heaven and wider than this earth have I become in greatness.

The hymns of the *Rgveda* were collected from different regions in India around 800 B.C., and some may have been composed as early as 1300 B.C. See Arthur B. Keith, *The Religion and Philosophy of the Veda and Upanishads,* Harvard University Press, 1925), pp. 438, 445 f.

12. Cassirer, *Language and Myth,* p. 62; cf. p. 46; *The Philosophy of Symbolic Forms,* Vol. 2: 237 f.

13. Cassirer, *Language and Myth,* pp. 33; 36.

14. ibid., p. 88; cf. *An Essay on Man,* p. 110 f.

15. Usener, *Götternamen. Versuch einer Lehre von den religiösen Begriffsbildung* (Bonn, 1891), p. 290 f, quoted by Cassirer in *Language and Myth,* p. 18. R.H. Codrington has shown that in archaic societies the feeling of the sacred is not limited to any particular sphere of reality. Anything that captures the primitive's interest can acquire the character of the sacred ("momentary god"). For example, the words *mana* and *tabu* do not serve to designate specific classes of objects but can be attributed to any physical thing whatsoever, even if it is not regarded as the dwelling place of a spirit or demon; a thing is invested with the aura of holiness as soon as it can be distinguished by any special characteristic from the sphere of the customary and common. See Codrington, *The Melanesians,* Oxford, 1891, p. 253. With the passage of time the fear of spirits and demons surrounding the primitive, ceases to be an elemental bestial terror and turns into the experience of the numinous which, as Otto would have it, is at the same time accompanied by the contrary emotions of amazement and fascination. Finally this sense of wonderment which begins in myth issues in philosophical and scientific reflection. But it must be emphasized that this is not a linear development since the numinous in the sense of the imaginal remains the permanent basis of all our theoretical constructions. Cf. R. Otto, *The Idea of the Holy* (New York: Oxford University Press, 1958), pp. 1-41.

16. Hillman, *Re-Visioning Psychology,* p. 9. Hillman conceives rhetoric (the art of persuasion) as *"devotio,* an attempt to return the word to the Gods and to give appropriate form to the divine magic, the sacred breath in language" ("On the Necessity of Abnormal Psychology," p. 120).

17. According to Langer, the mythical interpretation of reality rests on the principle that "the veneration appropriate to the meaning of a symbol is focused on the symbol itself, which is simply identified with its import" ("On Cassirer's Theory of Language and Myth," p. 388). This seems to say that the primitive combines what we today mean by the literal and symbolic approaches. As Barfield has observed, our "symbolical" is an approximation of *their* "literal," for "the essence of symbolism is, not that words or names, as such, but that things or events themselves, are apprehended as representations" (*Saving the Appearances,* p. 87; cf. p. 54f).

18. Cassirer, *The Philosophy of Symbolic Forms*, Vol. 3: 114; cf. p. 115; Hillman, "An Inquiry into Image," p. 64.

19. Cassirer, Vol. 2: 89.

20. See J. Huizinga, *The Waning of the Middle Ages* (London: Edward Arnold, 1924), pp. 136-159.

21. Cassirer, Vol. 2: 252; cf. pp. 24-25.

22. W.M. Urban, "Cassirer's Philosophy of Language," *The Philosophy of Ernst Cassirer*, p. 424.

23. Cassirer, Vol. 2: 252.

24. ibid., p. 261; cf. p. 239. According to E. Kahler, " . . . genuinely mythical and cultic works are not intended as symbolic representations, they are meant to describe real happenings. In the early ages . . . reality is so monumentally plain, so naturally comprehensive, undisclosed like a bud, that it holds for us a dormant wealth of meaning, all but inexhaustible . . ." ("The Nature of the Symbol" in *Symbolism in Religion and Literature*, ed. Rollo May, New York: G Braziller, 1960, p. 65.)

25. Hillman, *Re-Visioning Psychology*, pp. 89; 88.

26. David L. Miller, *The New Polytheism: Rebirth of the Gods and Goddesses* (New York: Harper & Row, 1974), p. 56; cf. G. Van der Leeuw, *Religion in Essence and Manifestation*, Vol. 1: 180, (New York: Harper & Row, 1963).

27. See Hillman, *Re-Visioning Psychology*, p. 169; cf. "Anima," p. 127.

28. See Hillman, *Re-Visioning Psychology*, pp. 227, 170.

29. *CW* 17, ¶ 291; cf. Miguel Serrano, *C.G. Jung and Hermann Hesse; a Record of Two Friendships* (New York: Schocken Books, 1966), p. 10.

30. Hillman, "Anima (II)," *Spring 1974*, p. 138; cf. *CW* 14, ¶ 128; Hillman, *Re-Visioning Psychology*, p. 228.

31. Hillman, "Psychology: Monotheistic or Polytheistic?," *Spring 1971*, p. 201.

32. Watkins, *Waking Dreams*, p. 99.

33. Cassirer, *The Philosophy of Symbolic Forms*, Vol. 2: 247.

34. T.R.V. Murti, *The Central Philosophy of Buddhism; a Study of the Madhyamika System* (London: Allen and Unwin, 1960), p. 274.

35. Cassirer, *The Philosophy of Symbolic Forms*, Vol. 2: 217.

36. Robert S. Hartman, "Cassirer's Philosophy of Symbolic Forms," *The Philosophy of Ernst Cassirer*, p. 324.

37. The Middle Way (*Madhyamika*) of the Mahayana School propounds the "Middle path" between materialism and sensuous indulgence, on the one hand and rationalism and asceticism, on the other. The *Madhyamika* was started by Nagarjuna (2nd century A.D.) and is characterized by its use of the term *sunyata* — a method of expounding the "voidness" of ultimate reality and permanence of all concepts. Later the term *nirvana* was identified with *sunyata*. See T.O. Ling, *A Dictionary of Buddhism* (New York: Scribner's, 1972), pp. 185, 196, 20, 22.

38. Cassirer, *The Philosophy of Symbolic Forms*, Vol. 2: 134; 135.

39. Cassirer, *An Essay on Man*, pp. 147; 148; cf. p. 170.

40. Cassirer, *The Philosophy of Symbolic Forms*, Vol. 2: 137.

41. On the spontaneous historicizing of the psyche and the necessary

Notes

connection between imagination and memory see Hillman, "The Fiction of Case History: a Round," pp. 162-170; *The Myth of Analysis*, section "Psychology's Loss of Memory," pp. 169-182.

42. Suzuki, *Essays in Zen Buddhism* (Third Series) (New York: Samuel Weiser, 1971), p. 77.

43. ibid., p. 87; cf. p. 99 f; Heinrich Dumoulin, *A History of Zen Buddhism*, trans. by Paul Peachey (Boston: Beacon Press, 1963), p. 38 f.

44. Suzuki, *Studies in Lankavatara Sutra* (London: Routledge & Kegan Paul, 1930), p. 197.

45. C. Naranjo equates *alaya* with the totality of experience, human as well as non-human, which is available to man "as the reflection of all and everything upon the mirror of his (enlightened) mind; the projection of the macrocosm onto microcosm, in virtue of which it has been said: 'As above, so below'." "Vanishing Magician-Spectator, Rabbit, and Hat," in *Reflections of Mind*, ed. Tarthang Tulku (Dharma Publishing, 1975), pp. 50-51. It has also been suggested that *alaya* corresponds to the modern idea of the holographic nature of the universe as a consequence of which the whole is reflected in its parts. See Robert M. Anderson, Jr., "A Holographic Model of Transpersonal Consciousness," *The Journal of Transpersonal Psychology*, 1977, Vol. 9/2.

46. John White, ed., *The Highest State of Consciousness* (Garden City, N.Y.: Anchor Books, 1972), p. xii.

47. Suzuki, *Zen and Japanese Culture*, p. 144.

48. Hillman, *Re-Visioning Psychology*, pp. 68, 69.

49. When Heraclitus said that "a dry soul is wisest and best" (Fr. 46, Wheelwright), he spoke as a philosopher (not psychologist), presaging the "professional philosophers" of today's academia, the "gigolos of wisdom." This felicitous expression comes from E.G. Ballard, *Philosophy at the Crossroads* (Baton Rouge: Louisiana State University Press, 1971), p. 273n. In Hillman's opinion "the soul is better imagined, as in earliest Greek times, as a relatively autonomous factor consisting of a vaporous substance." The soul is "not a diamond but a sponge, not a private flame but a flowing participation, a knotted complexity of strands whose entanglements are also 'yours' and 'theirs.' The collective nature of soul's depth means simply that no man is an island" (*The Myth of Analysis*, p. 24.). According to Heraclitus "souls take pleasure in becoming moist" (Fr. 47, Wheelwright).

50. Hillman, *Re-Visioning Psychology*, p. 104.

51. Hillman, "On the Necessity of Abnormal Psychology," p. 96; cf. *Re-Visioning Psychology*, pp. 88-104.

52. Wheelwright, *Heraclitus*, fr. 99.

53. Hillman understands the Jungian notion of the regulative function of opposites (*enantiodromia*) in a more deeply Heraclitean sense. See "The Dream and the Underworld," p. 303n; cf. *CW* 7, ¶ 111.

54. Hillman, "On the Necessity of Abnormal Psychology," p. 96.

55. *Letters of Rainer Maria Rilke*, 1910-1924, trans. by Jane Bannard Green and M.M. Herter (New York: Norton, 1947), pp. 373-374.

56. Hillman, *Suicide and the Soul*, p. 76.

57. ibid., p. 71.

58. Hillman, *Re-Visioning Psychology*, p. 209.

59. ibid., p. 207.

60. Fr. 88 (Diels). We are young and old, *senex* and *puer* throughout the course of life. See Section 6 of Hillman's "Senex and Puer," Puer Papers, Spring Publ., 1979, pp. 30-38. Heraclitus makes the same point by identifying Hades, the God of death, and Dionysos, the God of vitality and life (Fr. 15). See Hillman's comment on this identification in *The Myth of Analysis*, pp. 277-278.

61. Barfield, *The Rediscovery of Meaning*, p. 30.

BIBLIOGRAPHY

1. Major Works by Barfield, Cassirer, Hillman, Jung

Barfield, Owen. *Saving the Appearances; a Study in Idolatry.* New York: Harcourt, Brace & World, 1965.
———. *Poetic Diction; a Study in Meaning.* Middletown, Conn.: Wesleyan University Press, 1973.
———. *The Rediscovery of Meaning and Other Essays.* Middletown, Conn.: Wesleyan University Press, 1977.
Cassirer, Ernst. *An Essay on Man; an Introduction to a Philosophy of Human Culture.* New Haven: Yale University Press, 1944.
———. *The Philosophy of Symbolic Forms.* 3 vols. Trans. Ralph Manheim. New Haven: Yale University Press, 1955-1957.
———. *Language and Myth.* Trans. Susanne K. Langer. Dover Publications, Inc., 1953.
Hillman, James. *Emotion; a Comprehensive Phenomenology of Theories and their Meaning for Therapy.* London: Routledge & Kegan Paul, 1960.
———. *Suicide and Soul.* Zürich: Spring Publications, 1964, 1976.
———. *The Myth of Analysis; Three Essays in Archetypal Psychology.* New York: Harper & Row, 1972.
———. *Re-Visioning Psychology.* New York: Harper & Row, 1975.
———. *Loose Ends; Primary Papers in Archetypal Psychology.* Zürich: Spring Publications, 1975.
———. *The Dream and the Underworld.* New York: Harper & Row, 1979.
Jung, C. G. *The Collected Works of C. G. Jung.* 20 vols. Trans. R. F. C. Hull. Bollingen Series XX. Princeton University Press, 1957-1979.

Bibliography

2. Books, Essays and Articles on Imagination,
Myth and the East

Abrams, M. H. *Natural Supernaturalism; the Tradition and Revolution in Romantic Literature.* New York: W. W. Norton & Co., 1971.

Avens, Roberts. "Silencing the Question of God: the Ways of Jung and Suzuki," *Journal of Religion and Health,* Vol. 16, No. 3, 1977.

————. "C. G. Jung and Some Far Eastern Parallels," *Cross Currents,* Spring 1973.

Bachelard, Gaston. *On Poetic Imagination and Reverie.* Trans. Colette Gaudin. Indianapolis: The Bobbs-Merrill Co., 1971.

————. *The Poetics of Space.* Trans. Maria Jolas. Boston: Beacon Press, 1969.

————. *The Poetics of Reverie.* Trans. Daniel Russell. Boston: Beacon Press, 1968.

Beguin, Albert L. *L'Ame romantique et le rêve.* Paris: Corti, 1960.

Bundy, M. W. "The Theory of Imagination in Classical and Medieval Thought," *University of Illinois Studies in Language and Literature* XII. Urbana, 1927.

Campbell, Joseph. *The Flight of the Wild Gander; Explorations in the Mythological Dimension.* Chicago: Henry Regnery Co., 1969.

Casey, Edward S. *Imagining; a Phenomenological Study.* Bloomington: Indiana University Press, 1976.

Christou, Evangelos. *The Logos of the Soul.* Zürich: Spring Publications, 1976.

Coleridge, S. T. *Biographia Literaria.* J. Shawcross, ed. Oxford, 1907.

Corbin, Henry. *Creative Imagination in the Sufism of Ibn Arabi.* Bollingen Series XCI. Princeton University Press, 1969.

————. "*Mundus Imaginalis* or the Imaginal and the Imaginary," *Spring 1972.*

Drummond, M. "The Nature of Images," *British Journal of Psychology,* XVII (1926) 1: 10-19.

Durand, Gilbert. "Exploring the Imaginal," *Spring 1971.*

————. "The Image of Man in Western Occult Tradition," *Spring 1976.*

Eliade, Mircea. *Myths, Dreams and Mysteries.* Trans. Philip Mairet. New York: Harper & Row, 1957.

Ellenberger, H. F. *The Discovery of the Unconscious.* London: Allen Lane, 1970.

Bibliography

Evans-Wentz, W. Y., ed. *The Tibetan Book of the Dead.* Oxford University Press, 1960.

Frankfort, Henri, et al. *Before Philosophy; the Intellectual Adventure of Ancient Man.* Penguin Books, 1967.

Gill, Barbara Fisher and Randolph Severson. "C. G. Jung on the Psychological," *Spring 1979.*

Heidegger, Martin. *Poetry, Language, Thought.* Trans. Albert Hofstadter. New York: Harper & Row, 1971.

————. *On the Way to Language.* Trans. Peter D. Hertz. New York: Harper & Row, 1971.

Hopper, Stanley R. and David L. Miller, eds. *Interpretation: the Poetry of Meaning.* New York: Harcourt, Brace & World, 1967.

Kant, Immanuel. *Critique of Pure Reason.* Trans. N. Kemp Smith. London, 1929.

Kristeller, Paul Oskar. *Eight Philosophers of the Italian Renaissance.* Stanford University Press, 1964.

Langer, Susanne K. *Feeling and Form; a Theory of Art.* New York: Charles Scribner's Sons, 1953.

Lauf, Detlef Ing. *Secret Doctrines of the Tibetan Books of the Dead.* Trans. Graham Parkes. Boulder and London: Shambala, 1975.

Murti, T. R. V. *The Central Philosophy of Buddhism; a Study of the Madhyamika System.* London: George Allen & Unwin, 1955.

Nakamura, Hajima. *Ways of Thinking of Eastern Peoples: India - China - Tibet - Japan.* Honolulu: East-West Center Press, 1964.

Onians, Richard Broxton. *The Origins of European Thought.* New York: Arno Press, 1973.

Raine, Kathleen. *Blake and the Tradition.* 2 vols. Princeton University Press, 1968.

Rhode, E. *Psyche.* Trans. W. B. Hillis, 8th ed. London, 1925.

Sartre, Jean-Paul. *Imagination.* The University of Michigan Press, 1972.

Shri Shankaracharya. *Vivekachudamini.* Text in Devanagari with word-for-word translation, English Rendering and Comments. Swami Madhavananda, ed. Calcutta: Advaita Ashrama, 1970.

Shibles, Warren A. *Metaphor; an Annotated Bibliography and History.* The Language Press, 1971.

Snell, Bruno. *The Discovery of Mind; the Greek Origins of European Thought.* Trans. T. G. Rosenmeyer. Cambridge: Harvard University Press, 1953.

Bibliography

Stevens, Wallace. *The Necessary Angel; Essays on Reality and Imagination.* New York: Vintage Books, 1951.

Starobinski, Jean. "Jalons pour une histoire du concept d'imagination," *La relation critique.* Paris: Gallimard, 1970, pp. 174-195.

Suzuki, D. T. *Essays in Zen Buddhism.* 3 vols. New York: Samuel Weiser, Inc., 1970.

———. *Studies in the Lankavatara Sutra.* London: Routledge & Kegan Paul, 1930.

———. *The Zen Doctrine of No Mind.* New York: Samuel Weiser, Inc., 1977.

Voogd, Stephanie de. "C. G. Jung: Psychologist of the Future, 'Philosopher' of the Past," *Spring 1977.*

Warnock, Mary. *Imagination.* Berkeley: University of California Press, 1976.

Warren, E. W. "Imagination in Plotinus," *Classical Quarterly* 16, 1966.

Watkins, Mary M. *Waking Dreams.* New York: Harper & Row, 1976.

Wheelwright, Philip. *Metaphor and Reality.* Bloomington: Indiana University Press, 1962.

Whyte, L. L. *The Unconscious Before Freud.* New York: St. Martin's Press, 1978.

Woolger, Roger. "Against Imagination: the *Via Negativa* of Simone Weil," *Spring 1973.*

Yandell, James. "The Imitation of Jung," *Spring 1978.*

Yates, Frances A. *The Art of Memory.* University of Chicago Press, 1974.

Zimmer, Heinrich. *Philosophies of India.* New York: Meridian Books, 1957.

3. Books, Essays and Articles on Archetypal Psychology

Avens, Roberts. 'James Hillman: Toward a Poetic Psychology," *Journal of Religion and Health,* fall or winter, 1980.

Berry, Patricia. "On Reduction," *Spring 1973.*

———. "An Approach to the Dream," *Spring 1974.*

Boer, Charles and Peter Kugler. "Archetypal Psychology is Mythical Realism," *Spring 1977.*

Casey, Edward S. "Toward an Archetypal Imagination," *Spring 1974.*

———. "Time in the Soul," *Spring 1979.*

Goldenberg, Naomi R. "Archetypal Psychology after Jung," *Spring 1975.*

Bibliography

Hillman, James. "The Feeling Function," in Marie-Louise von Franz and James Hillman, *Jung's Typology*. Zürich, Spring Publications, 1971.

————. "The Great Mother, her Son, her Hero, and the Puer," in James Hillman et al, *Fathers and Mothers*. Zürich, Spring Publications, 1973.

————. "The Fiction of Case History: a Round," in *Religion as Story*, ed. James B. Wiggins. New York, Harper & Row, 1975.

————. "Peaks and Vales; the Soul/Spirit Distinction as Basis for Differences between Psychotherapy and Spiritual Discipline," in *Puer Papers*, ed J. Hillman. University of Dallas: Spring Publications, 1979.

————. "On the Necessity of Abnormal Psychology," *Eranos* 43-1974. Leiden, E. J. Brill.

————. "Pandämonium der Bilder: C. G. Jungs Beitrag zum 'Erkenne dich selbst'," *Eranos* 44-1975. Leiden, E. J. Brill.

————. "*Senex* and *Puer:* an Aspect of the Historical and Psychological Present," *Eranos Jahrbuch* XXXVI. Zürich, Rhein, 1964; also in *Art International* XV/1, Lugano, 1971.

————. "Psychology: Monotheistic or Polytheistic?," *Spring 1971.*

————. "Anima" (Part One) and "Anima II," *Spring 1973, 1974.*

————. "An Inquiry into Image," *Spring 1977.*

————. "Further Notes on Image," *Spring 1978.*

————. "Image-Sense," *Spring 1979.*

Kugler, Paul. "Image and Sound; an Archetypal Approach to Language," *Spring 1978.*

————. "The Phonetic Imagination," *Spring 1979.*

Miller, David L. *The New Polytheism: Rebirth of Gods and Goddesses.* New York: Harper & Row, 1974.

————. "Images of Happy Ending," *Eranos* 44-1975. Leiden, E. J. Brill.

Noel, Daniel C. "Seeing through the Pseudo-Myth of Modernity: Castaneda's Trickster-Teaching as Archetypal Psychologizing," *Arche* 3, Winter 1979.

Whan, Michael W. " 'Don Juan,' Trickster, and Hermeneutic Understanding," *Spring 1978.*